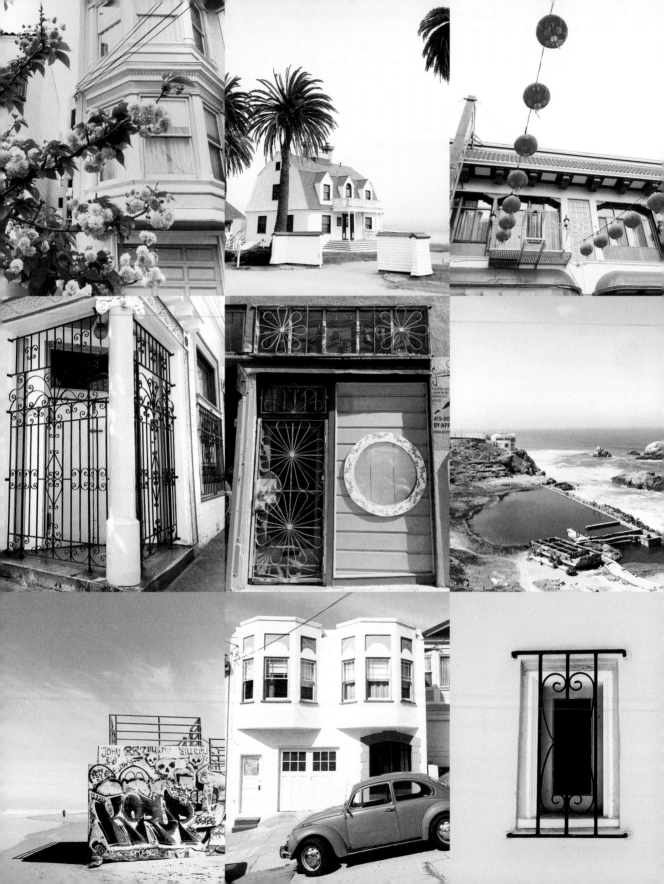

SEE SAN FRANCISCO

THROUGH THE LENS OF **SFGIRLBYBAY** VICTORIA SMITH

CHRONICLE BOOKS

SAN FRANCISCO

To my dad, who showed me the way to San Francisco. And to my mom, who passed along her creative genes and whose undying faith in me continues to help me find my way.

Library of Congress Cataloging-in-Publication Data available.

ISBN 978-1-4521-3820-6

Manufactured in China

Designed by Alice Chau

10 9 8 7 6 5 4 3 2 1

Chronicle Books LLC
680 Second Street
San Francisco, California 94107
www.chroniclebooks.com

CONTENTS

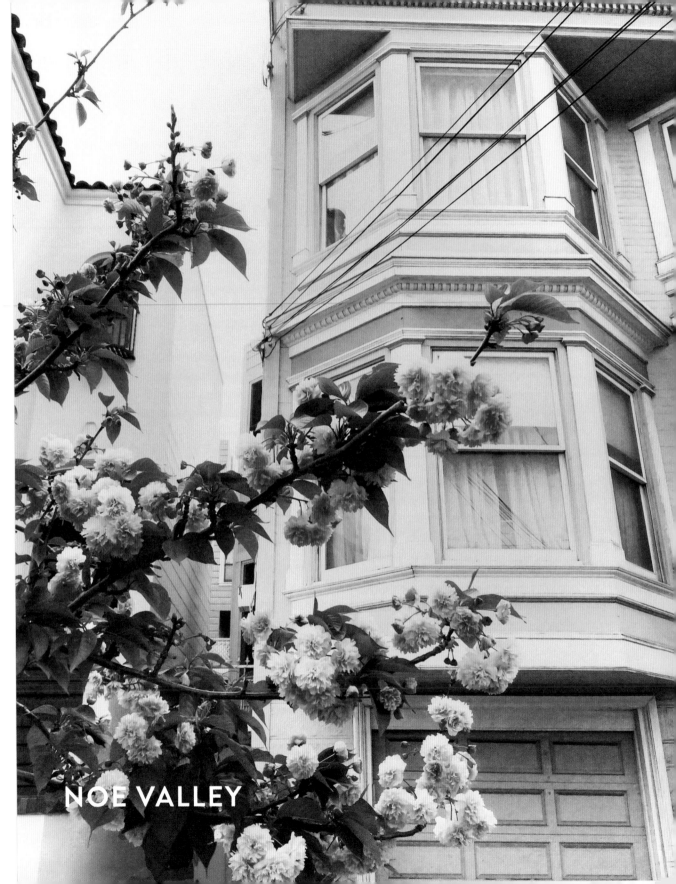

NOE VALLEY

I'm lucky enough to call Noe Valley home. Nestled below Twin Peaks and the steep, picturesque hills of the Castro and Glen Park, Noe Valley was settled and developed largely by Irish working-class migrants in the 1870s. To this day it has a friendly neighborhood-pub kind of vibe, plus a dash of S.F. hippie spirit. The sidewalks are filled with people walking happy dogs and young families pushing fancy strollers. There's a distinctive unpretentious laid-back local who calls Noe home; you might even call the neighborhood a throwback to the less-tech-driven San Francisco of the '70s and '80s. The coffee shops have Wi-Fi, but you're more likely to find people reading the *San Francisco Chronicle* or the *Noe Valley Voice* than blogging or discussing their latest start-up.

The shops along Noe's main drag, 24th Street, are uniquely San Franciscan. A stained-glass maker shares the block with indie fashion designers, specialty cheese and chocolate shops, bakeries, a few locals' bars, charming cafés, and a couple of gourmet wine shops. There is a pop-up organic farmers' market every Saturday, where a local jazz trio often plays.

The area is hilly with sweeping views. One of the best views in the city is from the tree swing at Billy Goat Hill. South of the hill is the small community of Glen Park, with its beautiful, lush seventy-acre canyon, great for weekend hikes. The canyon is one of the only places in the city with an actual creek running through it, and you may even spot a few coyotes running wild there.

Another thing I love about Noe is its location. Close enough to walk to Glen Park for a quiet dinner at the French café and a stroll around the Chenery Street shops, or to the hectic hipster-haven Mission District for a night out, but still a tad off the beaten track, Noe is tucked away in its sleepy valley beneath all those big, bright twinkling hills.

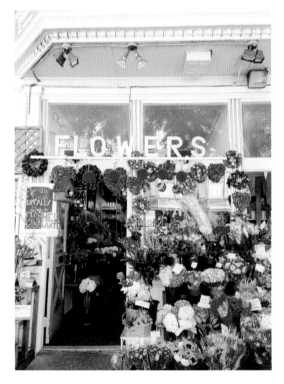

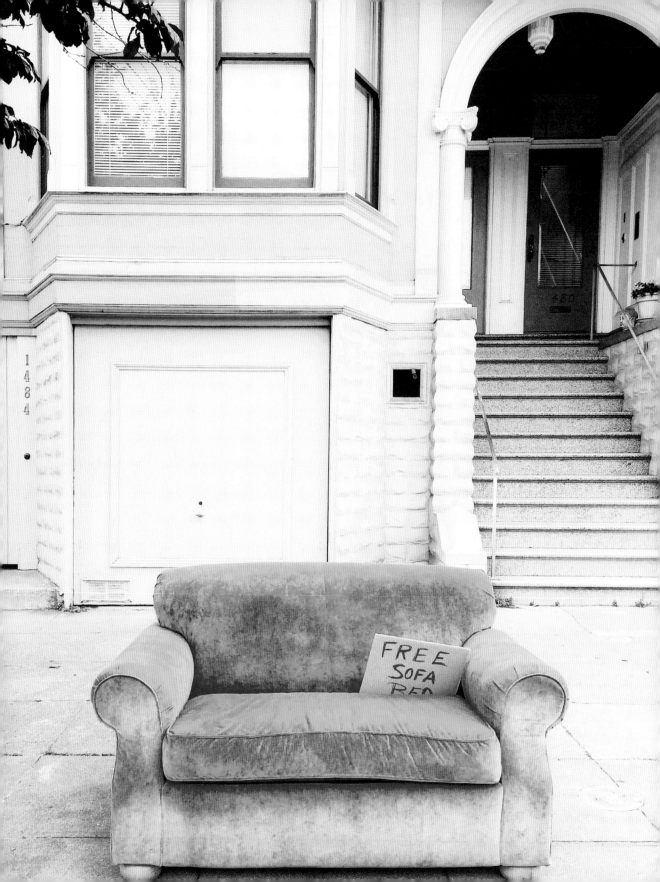

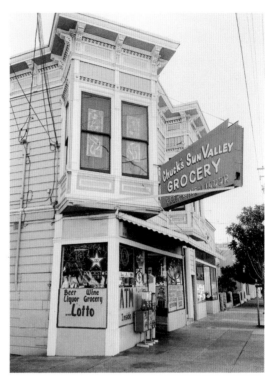

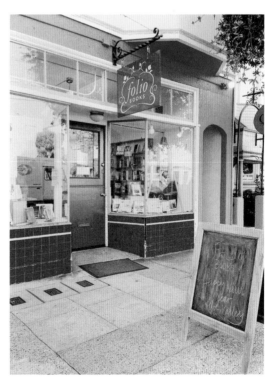

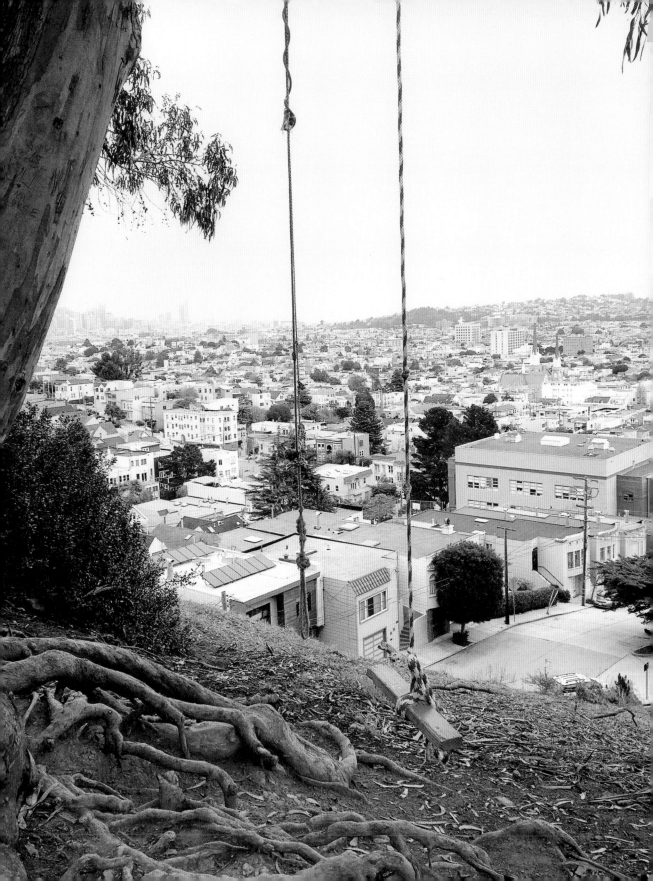

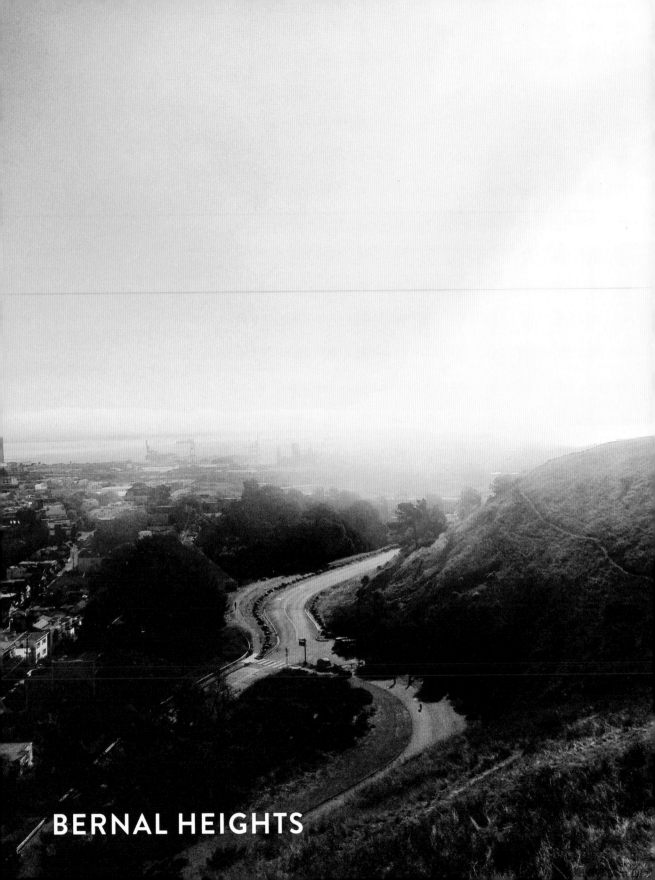

BERNAL HEIGHTS

I spend countless San Francisco mornings in Bernal Heights. I love hiking with my dog, Lucy, on the big twenty-six-acre Bernal Hill that defines the area and provides some of the city's best panoramic views. On Saturdays we scour the famous open-air Alemany Farmers' Market, one of the oldest farmers' markets in California (it has been open every Saturday in the same location since 1947!). It is one of my favorite markets for its variety of produce and general vibe: mellow and accessible. You may find a quirky musician playing an unrecognizable homemade instrument while children dance to the beat. Delicious locally made specialties like tamales, wood-fired-oven pizza, and Afghan breads and spreads are served fresh from food carts.

A flea market occupies the same space on Sundays. It's hit or miss, but I've found great vintage treasures there, so I like to go to see if I get lucky. Bernal Heights also hosts an annual neighborhood-wide summer yard sale that's a must-see, not just for the deals you can score, but for the genuine atmosphere of neighborly friendliness.

In fact, this whole neighborhood gives off that bygone small-town, homegrown vibe.

The main thoroughfare through Bernal is Cortland Avenue, which is sprinkled with tiny restaurants. Several neighborhood gems have been around for years, such as the local butcher and a charming little coffee roastery. There are older locals here, but recently lots of young families have moved into the neighborhood, too.

The area has many open stretches of grass for lounging on to catch some sun. On the south side of Bernal Heights sits Holly Park, and just below Bernal Hill to the north is Precita Park, constantly bustling with families and dogs. This lower and newly popular part of the neighborhood has a unique charm, and I can see it soon becoming a microneighborhood of its own. But it's Bernal Heights where I'm most likely to be found, with happy dogs running freely in the tall green grass and wildflowers that blanket the hillside in the springtime, which is my favorite season for spending time here up on the hill.

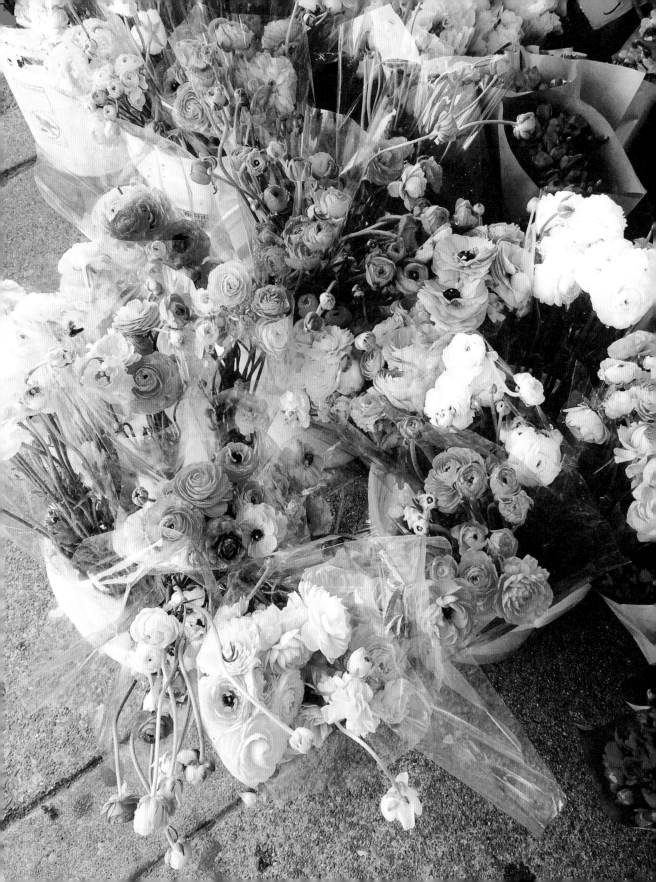

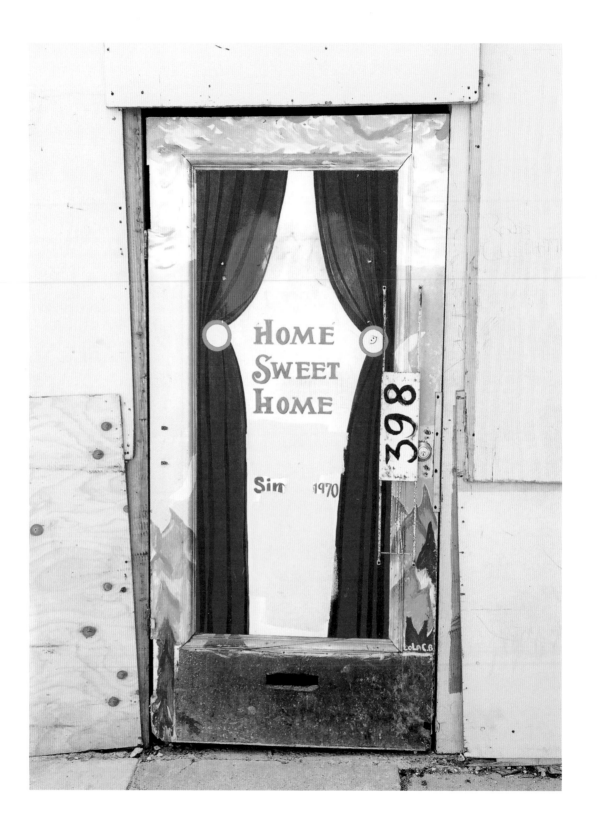

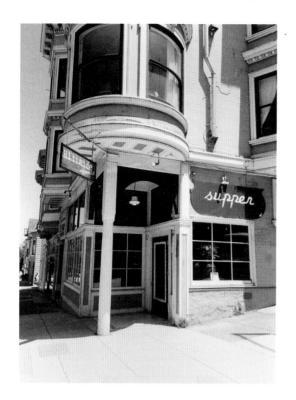

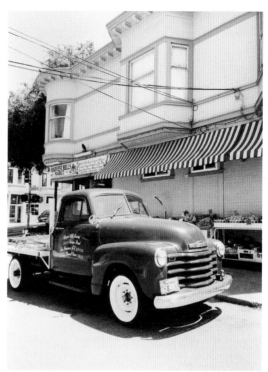

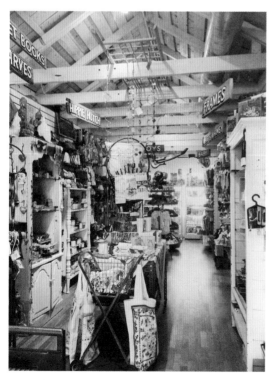

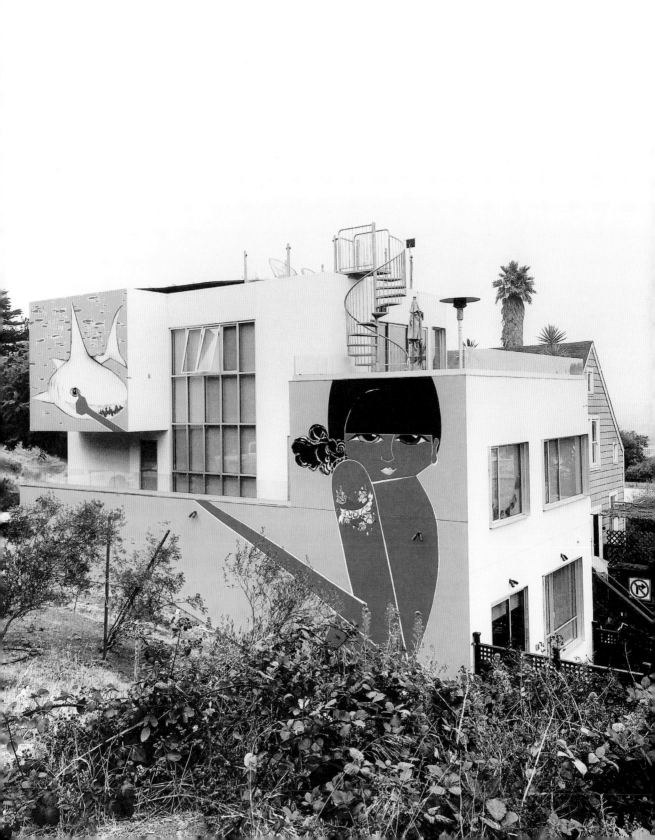

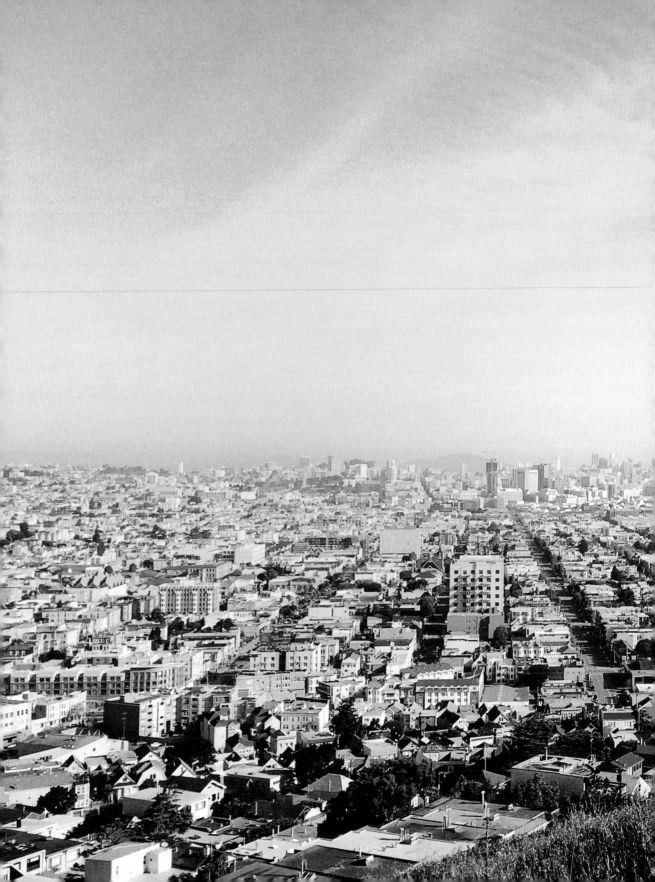

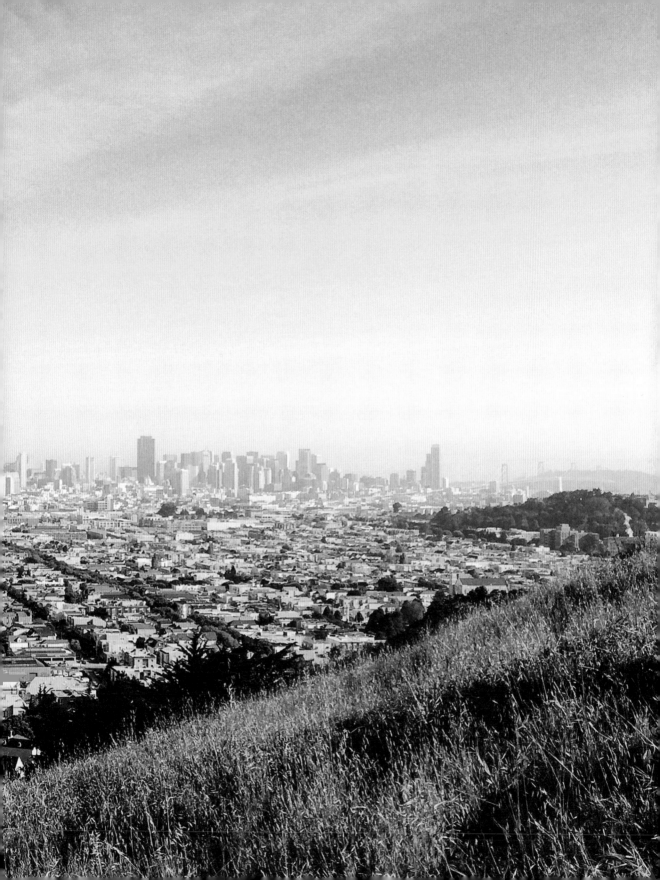

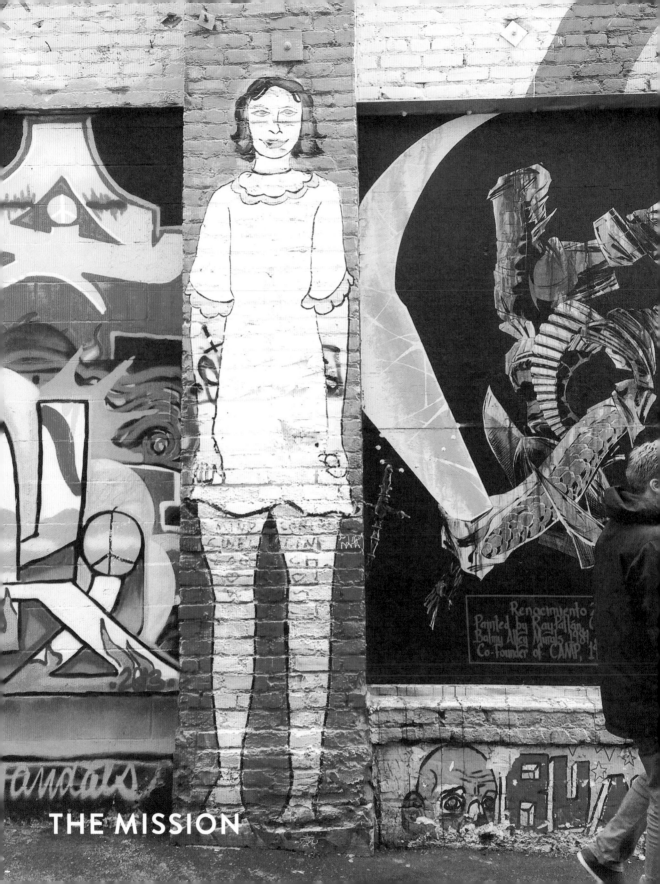

THE MISSION

The Mission District is actually considered the birthplace of San Francisco. It is home to San Francisco's oldest building, Mission Dolores, which was founded in 1776 and was a central place for the civic life of the city in its infancy.

In the late '90s, artists moved into the Mission for the cheaper rents and perpetually sunny weather. Since then, through the dot-com boom and in the years following, the area has become gentrified. It's a neighborhood that is steeped in history but also cutting edge—you'll find hipsters, tech moguls, and foodies among families that have lived here for generations.

Close to Mission Dolores is a big, sloping park dotted with palm trees. On a sunny S.F. day, *the* place to be is Dolores Park, a place I sometimes call Oz, with unsurpassed views of the glistening city and just about every type of San Franciscan soaking up the atmosphere (and sometimes soaking up much more—you may feel a contact high). On a nice weekend day, the park overflows with people—kids play on the playground while hippies form drum circles, girls hula hoop, revelers spread out with picnics, college students sunbathe, and dogs run from blanket to blanket. It's worth coming here for the people-watching alone.

The park is only one thing that makes the Mission one of my favorite areas. There's also a vibrant social scene and lots of culture and color. Entire city blocks, like Balmy and Clarion Alleys, are dedicated to street art and murals representing the rich history of the neighborhood. Plus, you can always find something interesting to do in the Mission, whether it's outdoor summer movie nights at Dolores Park, art exhibits in funky little pop-up galleries, or jazz at the Elbo Room, a classic bar that opened in 1935.

Along 24th Street east of Mission Street is where you will experience the authentic Latin American cultural roots of the Mission. Here, you can find the best tacos and burritos in town, pick up some piñatas for your next fiesta, and stop into a market for plantains and avocados at half the price of any grocery store. There's more variety and diversity in the Mission District than in any other neighborhood in the city, and that's exactly why it's a main attraction.

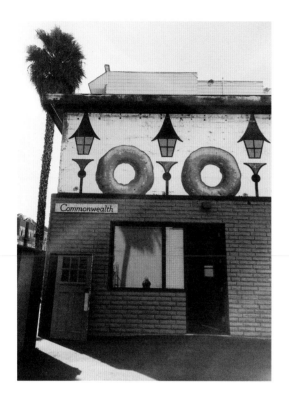

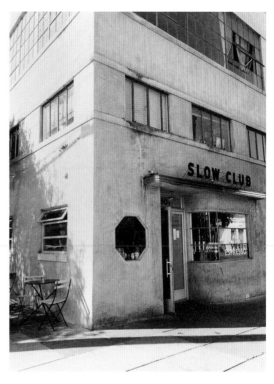

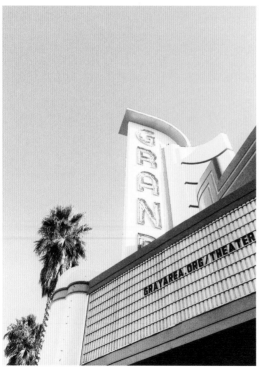

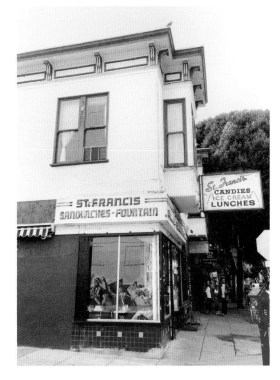

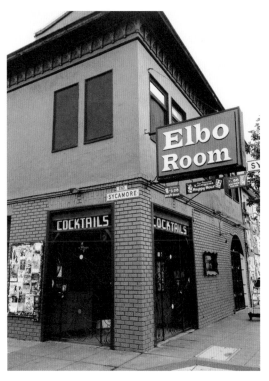

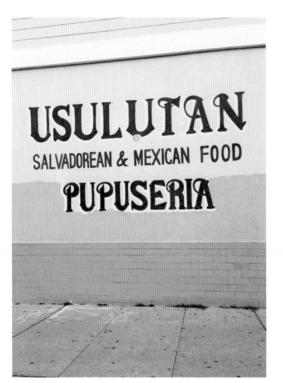

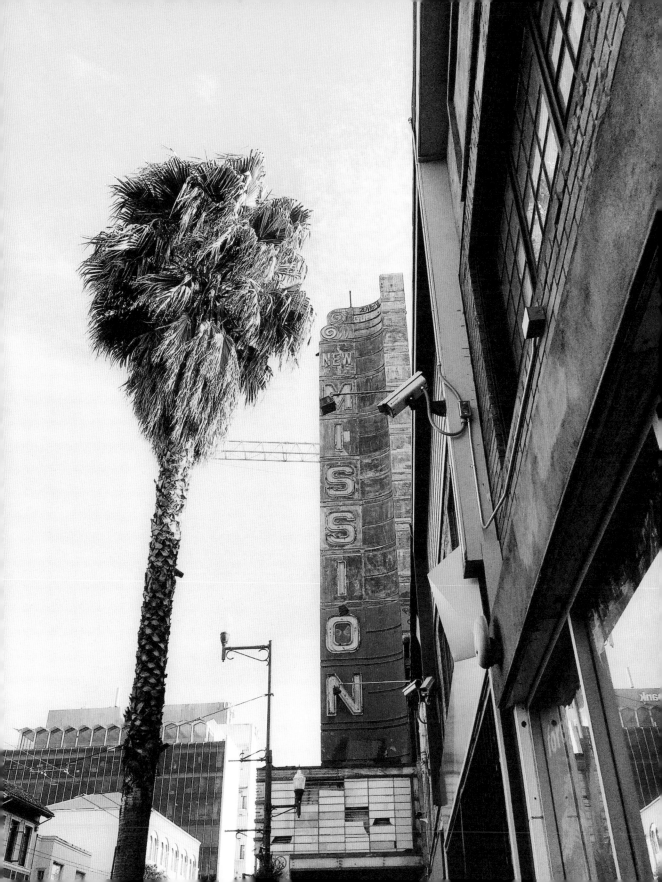

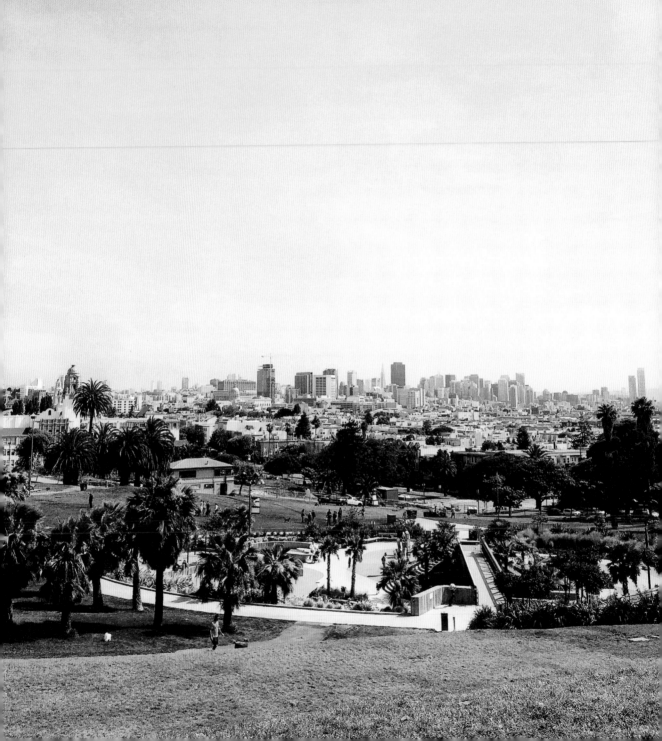

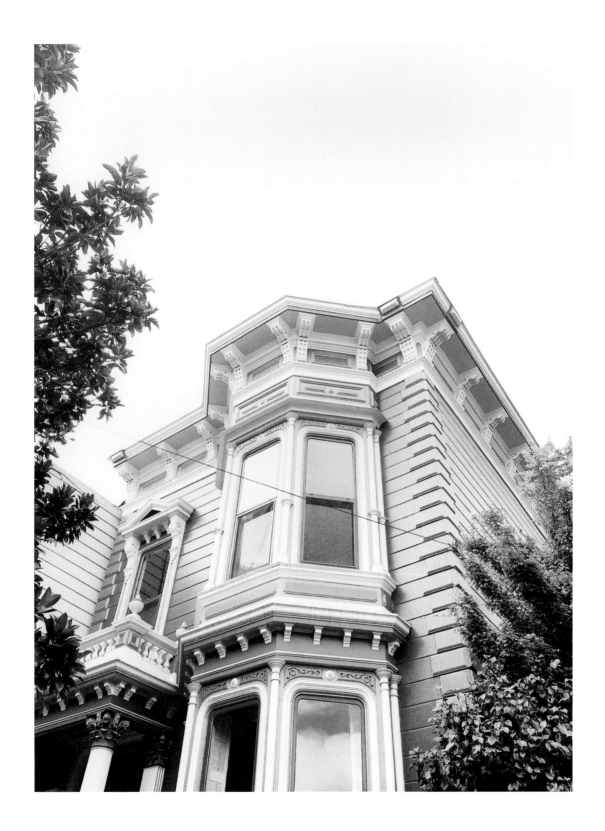

The unique thing about San Francisco is that one place grows out of itself into another, and suddenly there's a whole new destination to explore. Neighborhoods in San Francisco expand and change seemingly overnight. Potrero Hill and Dogpatch are prime examples of the constantly shifting trends in this ever-evolving city.

Potrero Hill is a sunny hillside neighborhood covered in pastel Victorians, with a beautiful community garden and a charming little downtown area with a popular coffee and magazine shop, a local grocer, tiny boutiques, and a multitude of charming cafés, most with outdoor seating to take advantage of the warmer weather found on the hill.

Lower Potrero is becoming increasingly lively and hosts some great galleries and shops, too, like Heath Ceramics, where you can watch artisans make their beautiful handcrafted wares. And there's an outcrop of new bars and cafés appearing along 20th Street.

Directly downhill from Potrero, straight below Missouri and 22nd Streets, is the area known as Dogpatch. The origins of this name are unknown, but one rumor says it's named for the packs of dogs that used to roam here. For a great walk, start up on Potrero Hill, taking in its breathtaking views of the bay and the San Francisco skyline, and then wander down to the former shipyards of Dogpatch.

Dogpatch was once an industrial neighborhood with long, low streets along the bay, huge brick warehouses, and homes that were built by the workers who lived there. Gentrification of this part of town started in the 1990s, and in recent years Dogpatch has become an enclave for artists and craftspeople.

With the influx of artists' studios came restaurants, small galleries, and shops. For such a small—and newly revitalized—neighborhood, Dogpatch has quickly gained a wide reputation throughout the city for excellent dining and culture.

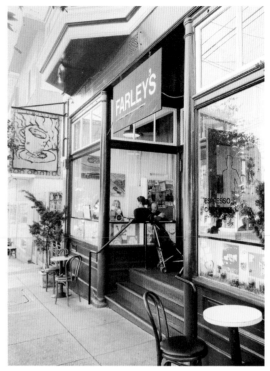

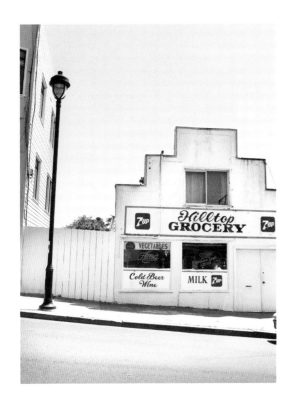

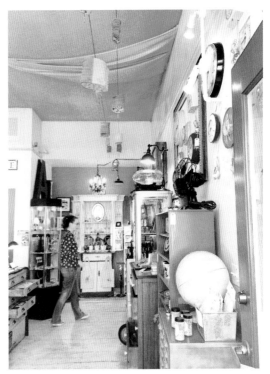

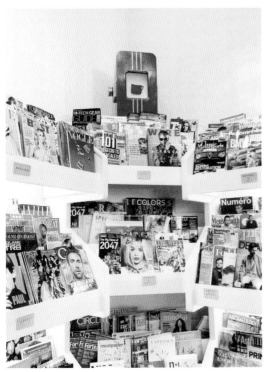

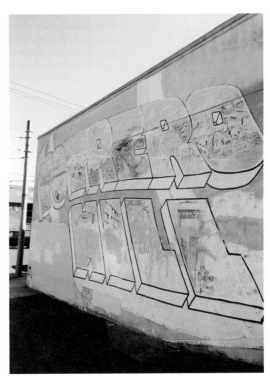

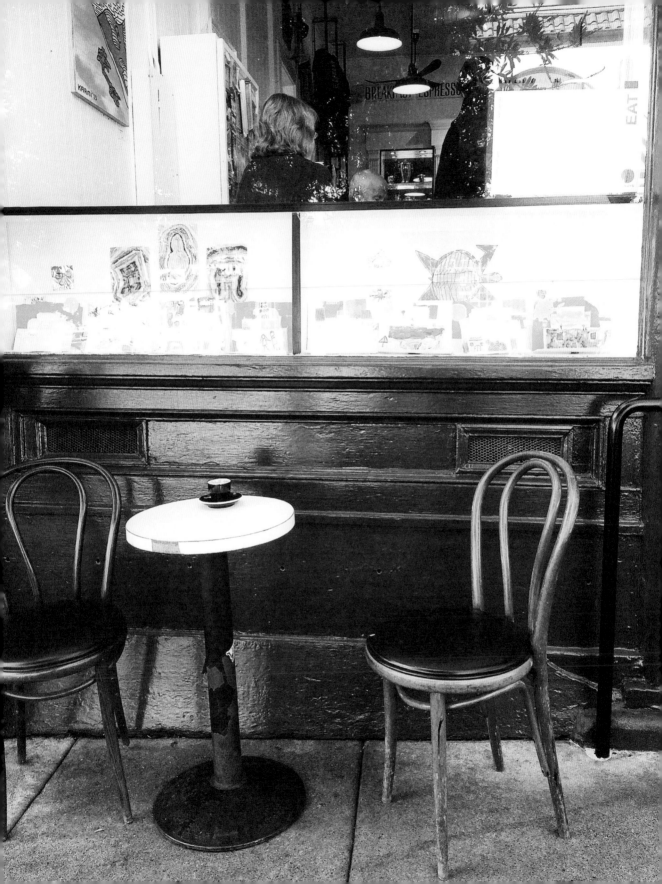

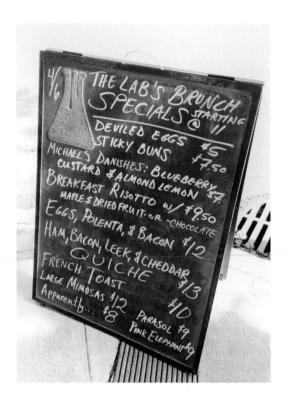

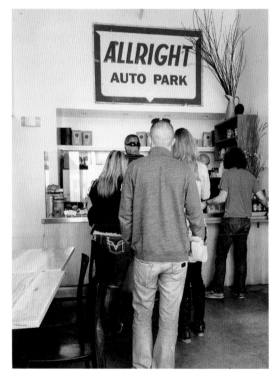

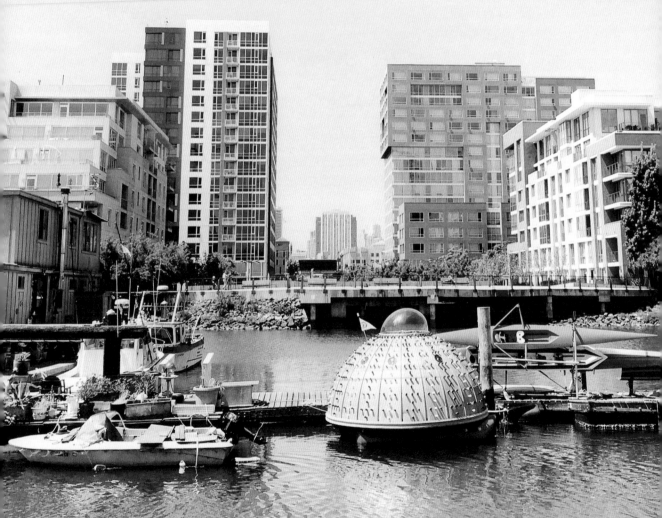

SOMA

SOMA stands for "South of Market," and it's changed drastically in recent years. Primarily an industrial area for decades, South of Market was not really a destination unless you had business there. But in 2000, with the construction of the major league ballpark, a whole new energy poured into this neighborhood.

Suddenly, shiny high-rise lofts shot up as hip new places to live, and restaurants with out-door dining opened to serve hungry and thirsty Giants fans and new residents. Beautiful well-worn brick buildings were reborn as swanky office spaces. What was once a dead-quiet neighborhood became lively and thriving.

But SOMA has a firm, if not incongruous hold on its history, too. There are a dozen or so aging and mossy houseboats clinging to the edge of narrow Mission Creek Marina near the ballpark, gently rocking in the looming shadows of downtown high-rises. South Park, which dates back to 1855 and is one of the city's oldest parks, still grows its pretty oval patch of grass, but its surrounding buildings now house trendy cafés and some of the city's biggest tech companies. On weekdays, the park is filled with young workers eating lunch and lounging in the grass.

With the addition of the ballpark and the rapid development around it, the city also spruced up the Embarcadero along the waterfront, adding wide, pleasant walkways and bike paths surrounding the bay, from which you can enjoy awesome views of the Bay Bridge and the East Bay beyond. But no matter the city's attempt at reinvention, history lingers on the Embarcadero, too.

A place that especially warms my heart is Red's Java House. One of the best dives in the city, Red's has been around since the 1930s and has survived a couple of fires and the 1989 earthquake to serve delicious and inexpensive burgers, hot dogs, and beer in a casual setting filled with character.

It goes without saying that San Francisco is known for progress, but it's defiantly old-school and audacious about its roots, too, and SOMA embodies that juxtaposition perfectly.

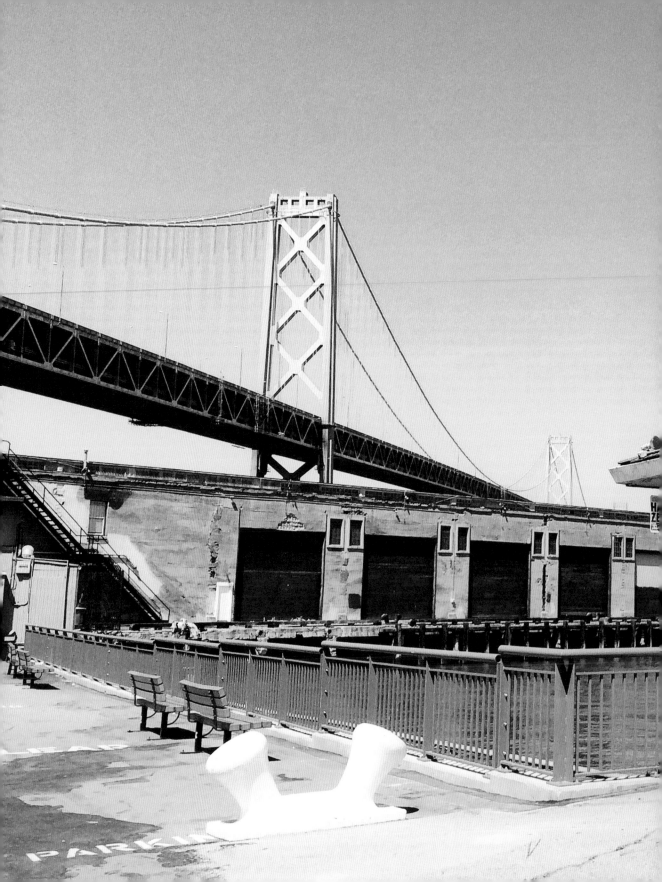

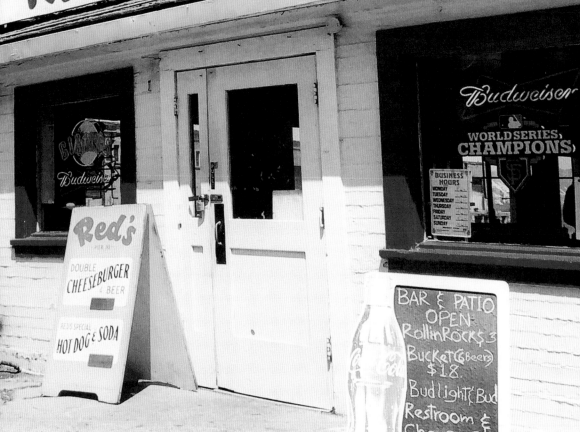

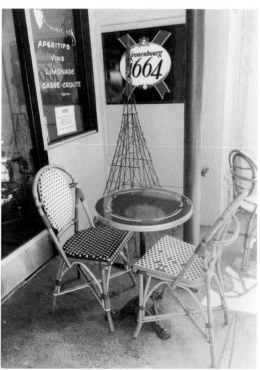

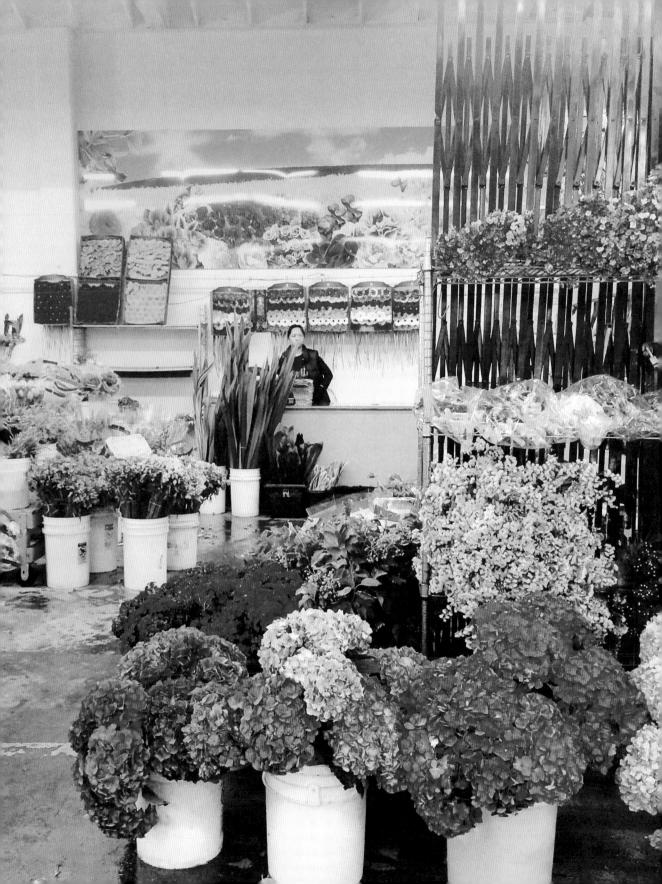

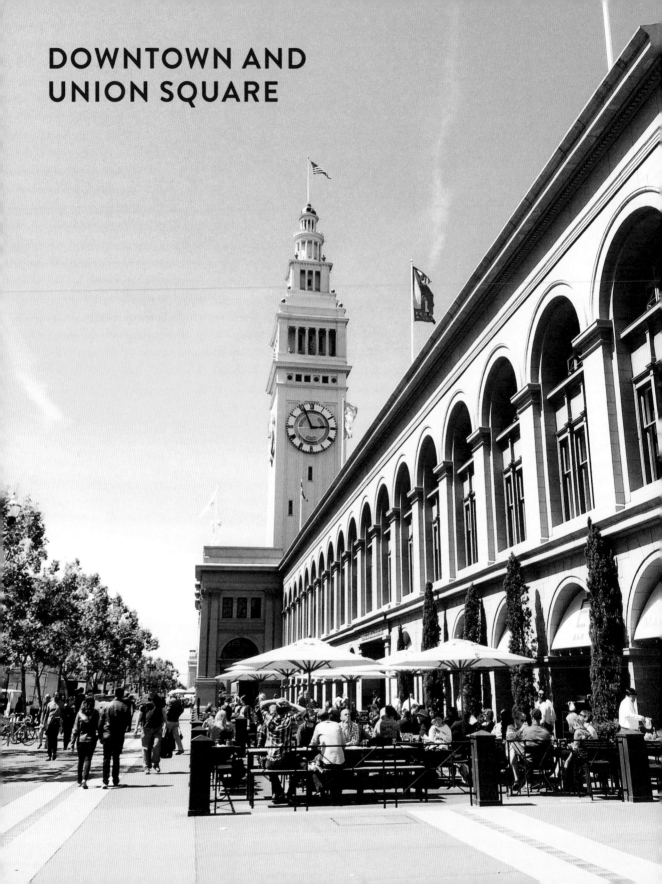

DOWNTOWN AND
UNION SQUARE

If you were to leave off at Red's Java House and head north along the Embarcadero, the wide waterfront walkway and seawall along the Port of San Francisco, an ideal way to travel is on one of the colorful vintage tram cars. The first streetcar was a gift from Milan in 1984, sent for the historic Trolley Festival. San Francisco dwellers liked it so much that the city ordered more historic cars from places around the world, including Australia, Portugal, England, and different regions of the United States. Now you can hop on a vintage streetcar on the F line and guess the country of origin while enjoying views of Market Street all the way from the bay to the Castro.

At the foot of Market Street is one of San Francisco's oldest landmarks: the Ferry Building with its iconic clock tower. Built in 1898, the Ferry Building welcomes daily commuters from the East and North Bay, who travel to and from work in quite possibly the most enviable fashion: on high-speed ferryboats. The boats run all day and even serve snacks and refreshments. Before the Golden Gate and Bay Bridges were built in the 1930s, the only way to reach the city was by boat, unless you were arriving from the Peninsula down south.

The Ferry Building is architecturally stunning, and was beautifully renovated in 2003. The Marketplace now houses cupcake bakeries, fishmongers, butchers, artisanal cheese makers, and a famous gourmet Vietnamese restaurant. A vast farmers' market selling locally grown organic produce is held here three days a week, and the length of the building's long, arched corridor brims with every food you'd ever want to sample.

From Market and California Streets, the cable cars ride up and over the hills through the canyons of towering skyscrapers of the Financial District. I like to hop off at Powell Street at the very top of Nob Hill and change cars to whoosh back down past Victorians and hotels into Union Square, San Francisco's shopping mecca.

The shopping in Union Square is grand, with swanky shops, huge department stores, and bustling crowds. But my favorite parts of Union Square are the tucked-away, tiny alleyways. Walk through a small iron gate onto Maiden Lane, which was originally named Morton Lane and once part of San Francisco's red light district. There's no indication of that now, with a quaint outdoor bistro and street musicians playing saxophones and cellos. If you roam just a little farther east down the alley, there's even a Frank Lloyd Wright building, the great Xanadu Gallery, built among a multitude of high-end, expensive boutiques.

Another alley, Belden Place, is much more epicurean, and probably San Francisco's closest thing to European dining al fresco. This hidden alleyway with its globe lights bobbing under the stars is my favorite spot to spend one of San Francisco's rare and wonderful warm summer nights.

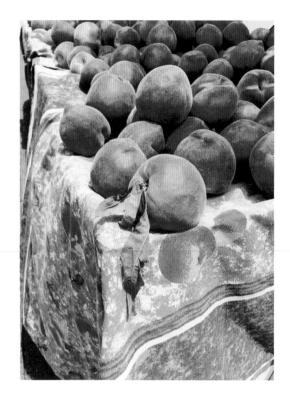

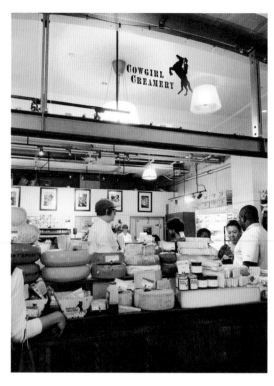

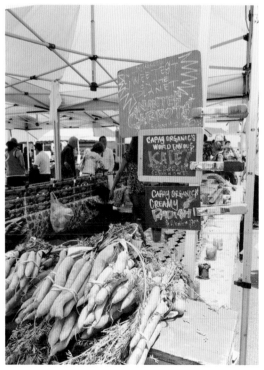

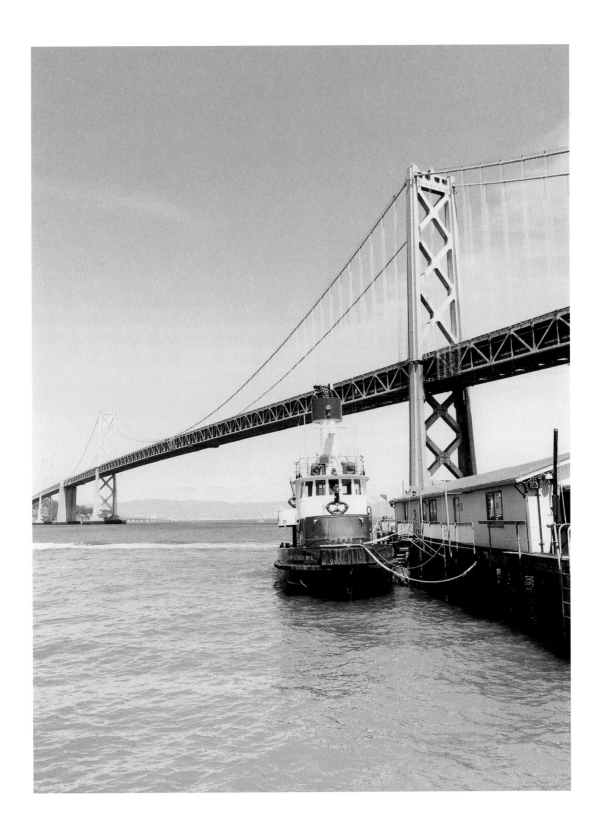

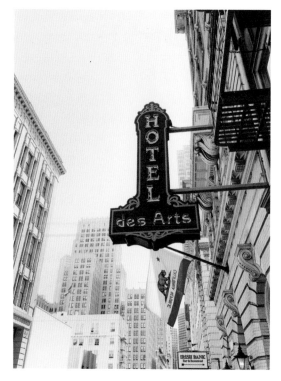

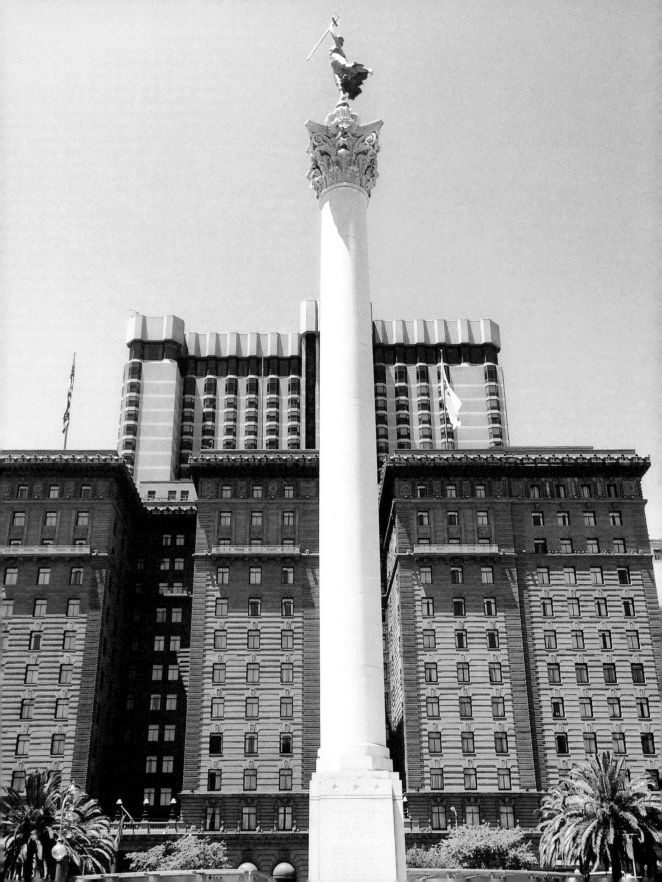

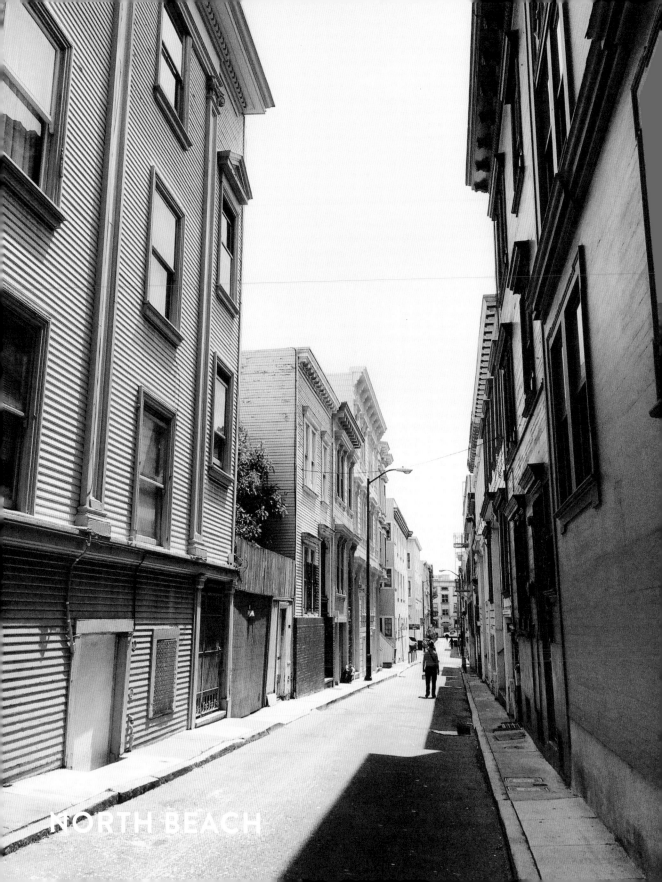

NORTH BEACH

I love history-soaked North Beach, considered San Francisco's Little Italy. In the late nineteenth century, thousands of Italian immigrants made their way to San Francisco and settled here. The charmingly authentic cafés with traditionally Italian green-and-red awnings send aromatic whiffs of garlic into the quaint, tiny streets. The area is home to some of the city's most delicious restaurants, and choosing just one can be a bit tricky, so it's best to wander around, sampling pasta or a panino in one spot, a gelato in another.

North Beach is nestled in a small valley under beautiful Telegraph Hill and Coit Tower, a monument built and completed in 1933 from funds donated to the city by Lillie Hitchcock Coit, an eccentric heiress who liked to wear men's clothes and hang out with the city's firefighters. Rumors surrounding Ms. Coit are as entertaining as the intriguingly shaped monument dedicated to her.

There's a gritty section of North Beach, too, along Broadway just beneath Telegraph Hill, whose sordid strip clubs and bars are a throwback to the area's original Barbary Coast days. In 1849, North Beach—named for the docks built on the northern side of the bay welcoming sailors and Gold Rush prospectors from all over the world—was a rough-and-tumble neighborhood with a reputation for gambling dens, saloons, and brothels.

But North Beach has a more literary history as well. In the 1950s it was home to the Beat Generation. Famous bohemian writers and poets, including Jack Kerouac and Allen Ginsberg, lived here, toiling over espressos at Caffe Trieste and doing readings at Lawrence Ferlinghetti's famed City Lights Books, which has remained one of the city's most-loved bookstores for more than fifty years.

A favorite lazy weekend pastime of mine is spending hours at City Lights browsing for a good book, grabbing a coffee, and finding a sunny spot to read in Washington Square Park, North Beach's grassy community center. I like to linger, watching Chinese neighbors perform their daily tai chi, then wander up through the lush backyard gardens of the Filbert Street Steps (hopefully spotting some of the wild green parrots who live there) and on up to Coit Tower for the stunning panoramic view of the bay. It's tough to imagine the chaotic madness the forty-niner Gold Rush brought to this peaceful, pretty place, but it's certainly fun to try.

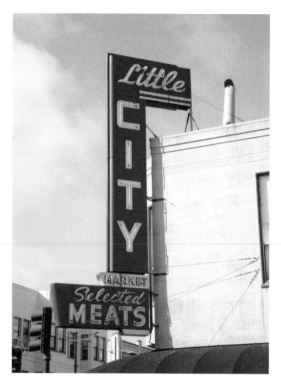

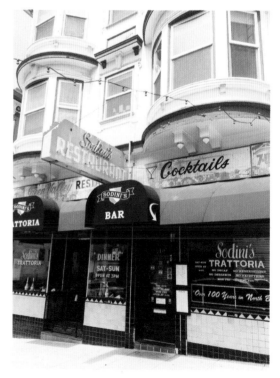

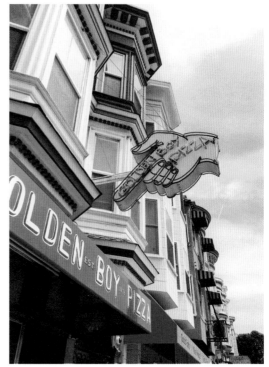

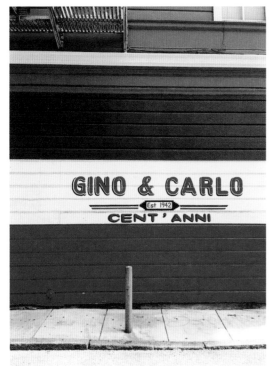

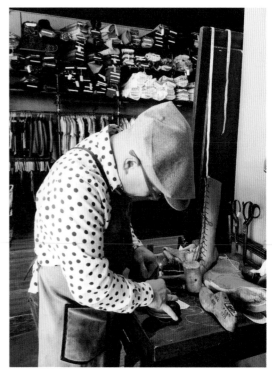

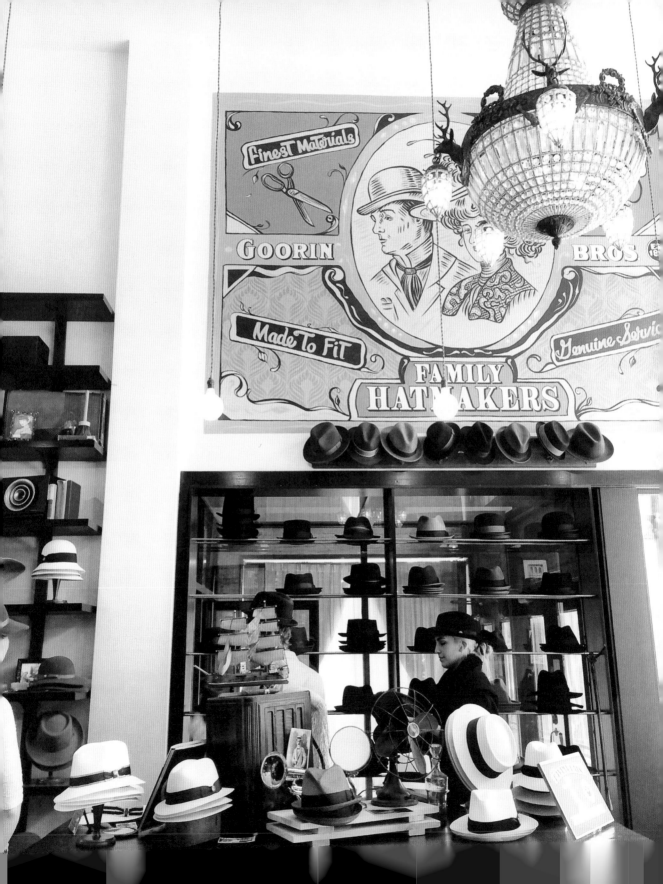

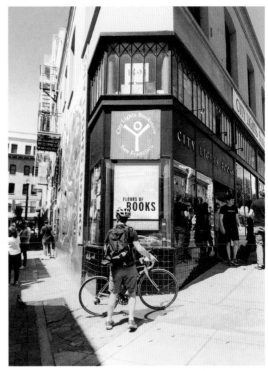

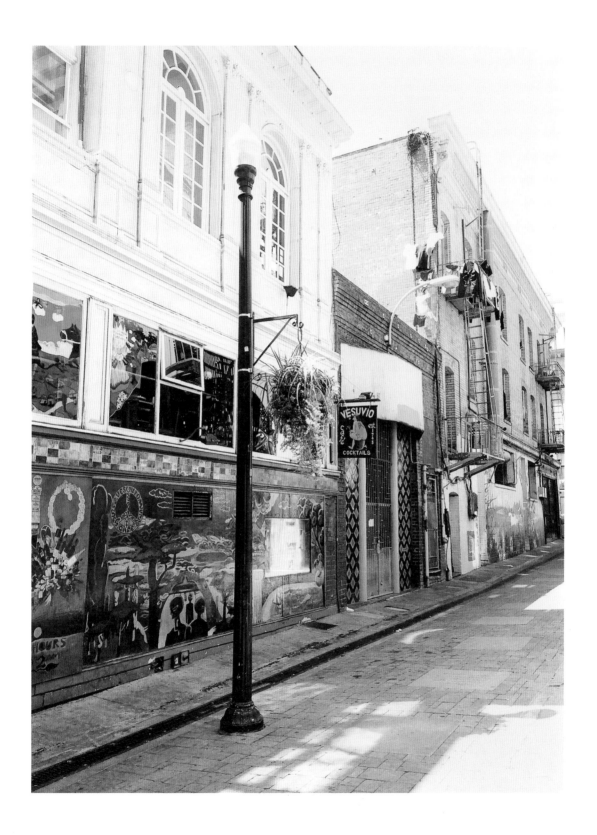

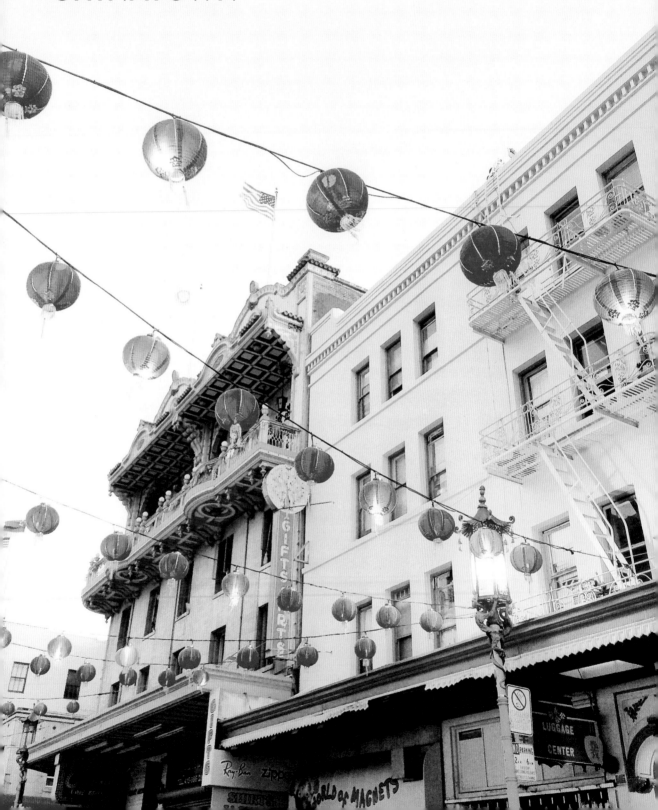

CHINATOWN

Chinatown and North Beach geographically overlap, but their cultures couldn't be more different. San Francisco's Chinatown is the largest outside of Asia, and the oldest in North America. It feels authentic and timeworn and more like you've traveled to another country rather than crossed a few city blocks from Little Italy.

To experience the full effect of this fascinating place, I like to enter Chinatown's main artery, Grant Avenue, through the enchanting, ornate arched Dragon Gate off Bush Street and wander through the crowded and colorful neighborhood from there. Tiny family-owned shops filled with tea, herbs, and delicacies crowd the sidewalks. Rows of Peking ducks hang from windows steamed up from delicious dim sum cooking within.

There are so many markets it's difficult to know which are the best, so I seek out the shops crowded with ladies who look like they know what they're doing, squeezing produce and jostling for the freshest fish. You'll find loads of small treasures and trinkets here, from silk slippers to sparklers to lucky Chinese Buddha bobbleheads (rumored to be good parking karma in a neighborhood nearly impossible to navigate by car).

Stroll down Ross Alley to discover a spot truly filled with good fortune, the Golden Gate Fortune Cookie Factory, which has been supplying fortune cookies to Chinatown and beyond since the early 1960s. The smell of freshly made fortune cookies will beckon you inside for a tour, but before you snap a photo, be sure to pay the fifty-cent fee up front—otherwise, you will hear it from the shopworkers! You can buy a big bag of cookies for just a few bucks.

For the most magical experience, I head to the neighborhood after dark, when China-town's nostalgically kitschy neon signs illuminate the back alleys and the lanterns strung across the streets glow and sway festively. Chinatown is always captivating, but it is a little bit more mysterious at night. Its tiny, cavelike dive bars are lively with tourists enjoying umbrella-embellished fruity cocktails and pu pu platters that even locals will order without embarrassment. It's the kind of weirdly wonderful neighborhood that welcomes all types of people, and though Chinatown is ancient, it just never seems to get old.

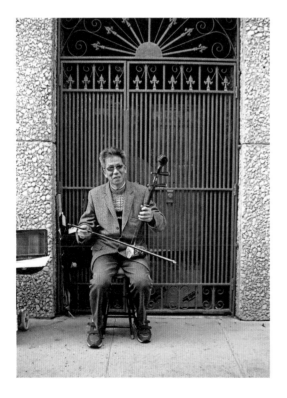

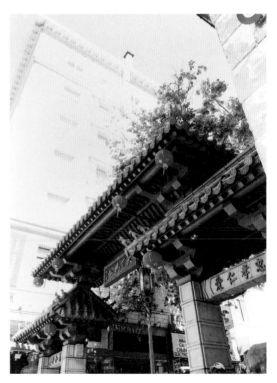

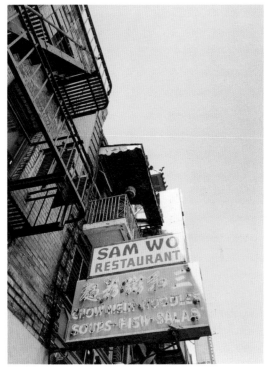

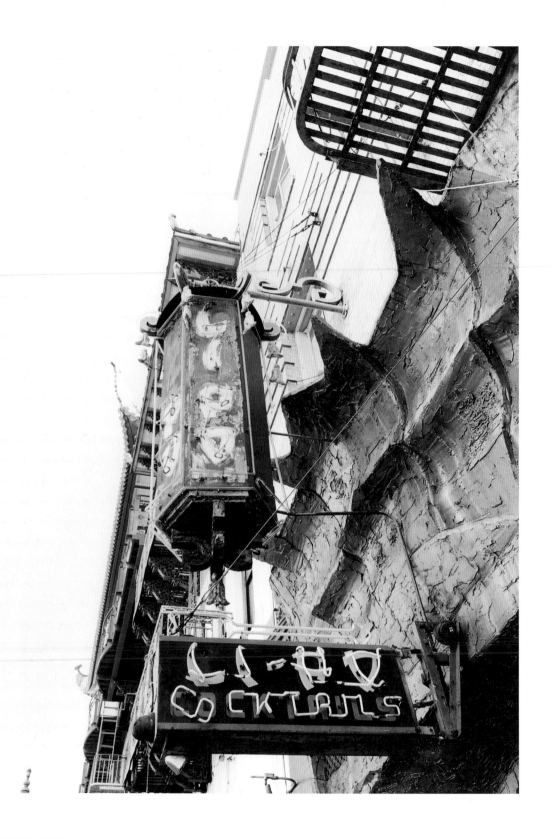

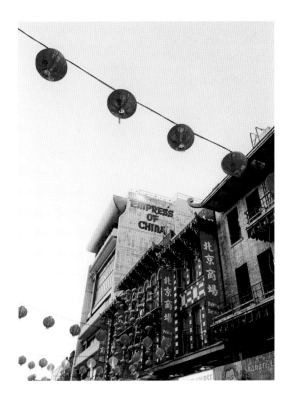
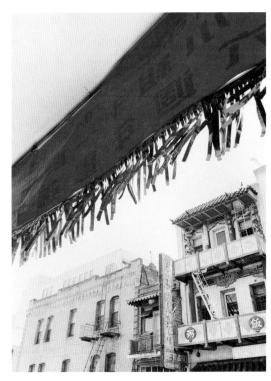
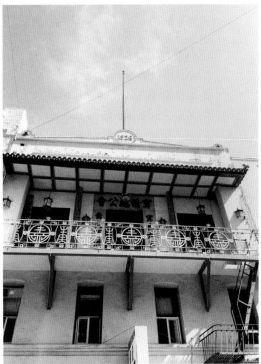
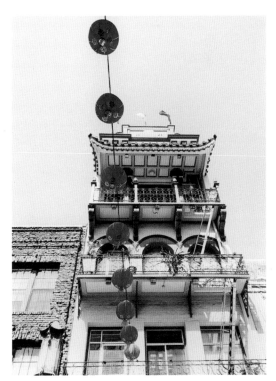

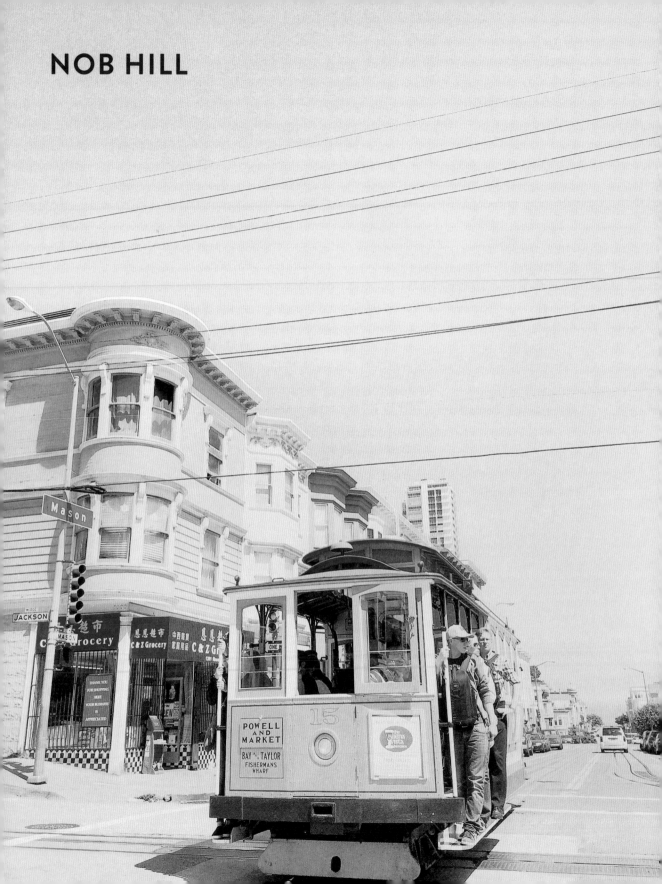

To visit Nob Hill is to step back in time. It has a very "noir" feel to it. In fact, it was made famous in part by Alfred Hitchcock's classic noir film *Vertigo*. Nob Hill is one of the swankiest spots in the city, and is quintessential San Francisco. The luxurious Fairmont and Mark Hopkins hotels sit atop California Street and share the block with Huntington Park and the Flood Mansion, one of the last standing mansions from the Gold Rush days.

One of my favorite places to take someone visiting San Francisco is the Top of the Mark, a cocktail lounge crowning the Mark Hopkins Hotel with unsurpassed panoramic views of the skyline. It is the absolute best place to see a city sunset.

Nob Hill has always been exclusive, but it was also literally somewhat inaccessible until the invention of the cable cars, which still regularly run up and down these steep hills, clanging away all day long. There's nothing quite like the joy of hanging on for dear life as a crowded cable car lurches up and down California Street.

If you take the cable car down California Street, you'll stop near the entrance to China-town; keep going east and you'll arrive in the Financial District downtown. If you head the other way, you'll land in quite the opposite end of the spectrum, the Tenderloin, which is San Francisco's seedier part of town.

Part of the Tenderloin is also known as Little Saigon, and you can eat a delicious Vietnamese meal here for next to nothing. Some galleries and shops have moved into this area, as well as several large tech companies, but it definitely still has some grit to it.

The soul of the neighborhood is Glide Memorial Church. People line up to get in because the service is more of a big party than typical church, and the Glide choir's gospel singing will lift your heart way higher than the Nob Hill cable cars have ever gone.

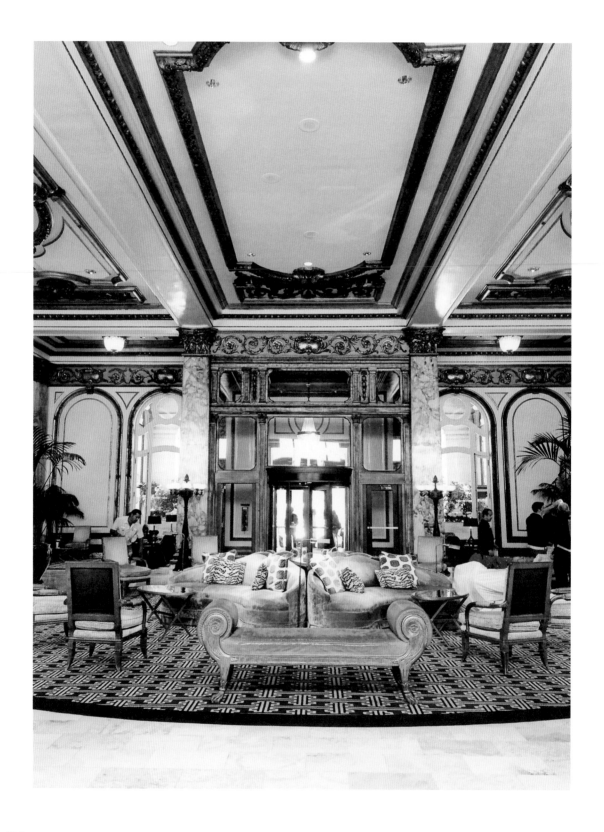

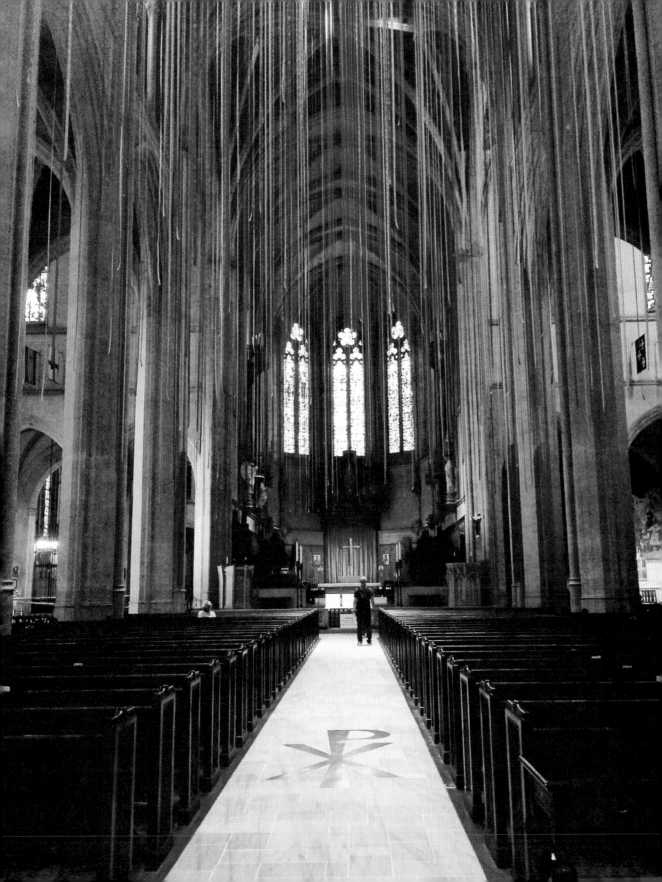

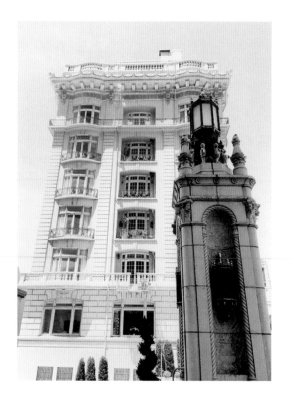

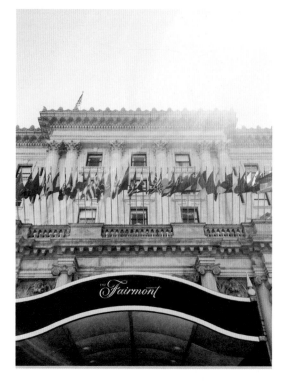

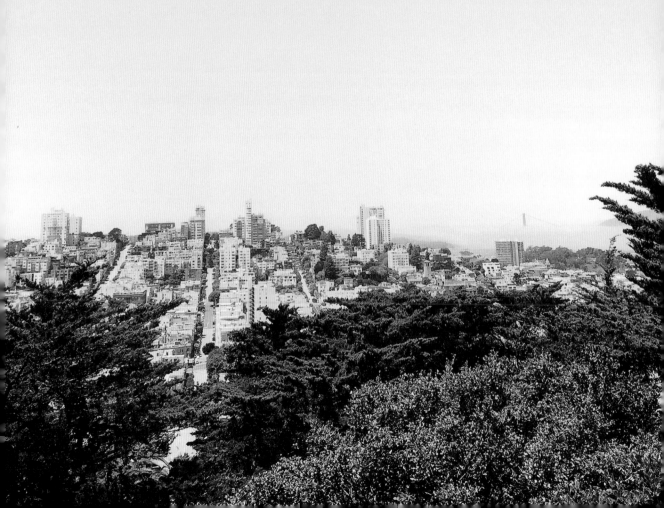

Russian Hill, just to the north of Nob Hill, is one of San Francisco's prettiest neighborhoods, with its massive hills, 360-degree bay views, beautiful homes, and cable cars clanking through the streets. I lived here for a spell, in an apartment on Polk Street at the foot of the steep hill before Lombard Street, often called the "crookedest street in the city" (which is incorrect—the most winding street is actually Vermont Street in Potrero Hill). From my balcony I'd watch tourists line up in their rental cars to wind down this beautifully groomed, hydrangea-covered street with eight very sharp hairpin turns. I still take visitors here—it's just random enough to be fun.

But the more enchanting and peaceful places to explore in Russian Hill are the hidden streets the neighborhood is famous for. The balustrade at Jones and Vallejo at the summit of Russian Hill is a brick-paved stretch lined with architectural gems designed by the likes of Willis Polk and Julia Morgan. Walking down this block makes you feel like you've stepped into a small European village. At the end of this street is a dinky public park that looks like it's been plopped down on the hillside, hovering precipitously above downtown.

Another favorite is Macondray Lane, made famous by Armistead Maupin's *San Francisco Chronicle* column-turned-novel, *Tales of the City,* in which it was fictionally named Barbary Lane. It's a tiny two-block walkway, just wide enough for foot traffic and filled with sweet little cottages and lush, overgrown urban gardens. This is a wonderful place to stroll after a trip to Swensen's Ice Cream Parlor, which has been at the corner of Union and Hyde Streets, along the cable car line, since 1948.

Russian Hill is mostly quiet and residential, but there's a smattering of shops and some great French cafés along Hyde Street, and if you wander farther west along Polk Street from Union Street you'll discover Polk Gulch, the main commercial area with antique and book shops, unique clothing and gift boutiques, and lots of restaurants. On weekend mornings Polk Gulch is a popular locals' spot for brunch, and a great place for people-watching while leisurely lingering over coffee at one of the many sidewalk cafés. In the evening it grows lively again with a younger crowd that pours in for the small bars and noisy nightclubs while the enclaves high on the hill sparkle soundlessly.

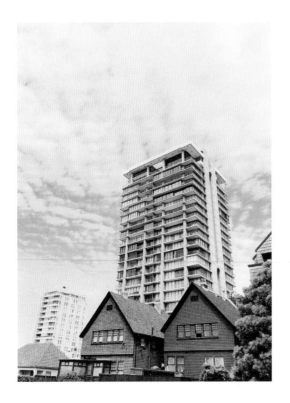

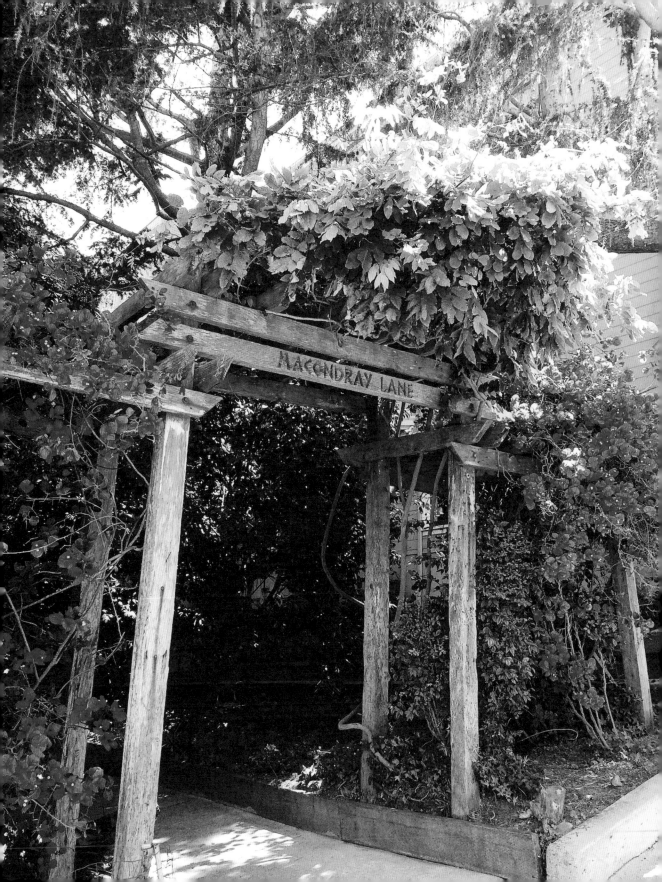

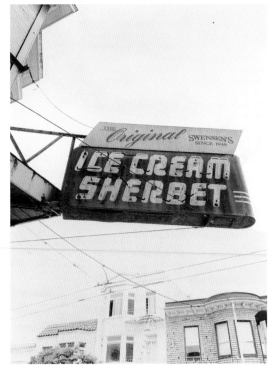

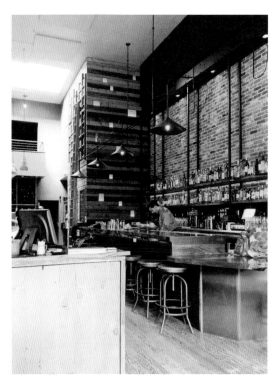

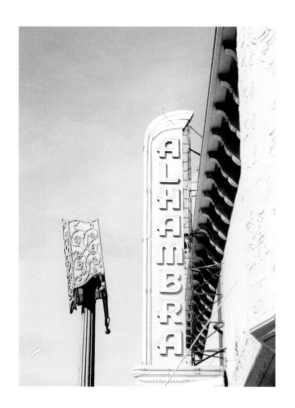

ESPRESSO BAR

ESPRESSO	2.75
AMERICANO	3
LATTE	3.75
CAPPUCCINO	3.5
CORTADO	3.5
MACCHIATO	3
MOCHA	4
CAFE AU LAIT	3.5
CHAI	3.5
HOT COCOA	2.75

BREWED COF
POUR OVER
KYOTO
COLD BREW
LOOSE LEAF
CUP
POT
LARGE POT
SMOOTHIES
STRAWBERRY
MANGO
BANANA OAT
BOTTLED D
WATER
COCONUT WAT
SAN PELEGR

SPECIALS

word to
your mama

THE MARINA

Located along San Francisco's northern waterfront, where the Pacific meets the Golden Gate's gorgeous entrance to San Francisco Bay, the Marina is a wonderful place to spend an afternoon outdoors. West of the docks of the Marina is Crissy Field, where I often bring my dog for a long walk along the water to a cute (and appropriately named) café, the Warming Hut, nestled near the often chilly base of the Golden Gate Bridge. The community and the National Park Service have restored this area into a coastal habitat, cultivating native plants in hopes of bringing back the wildlife that once thrived here. Cyclists, runners, baby strollers, and pups share the wide paths offering views of the bridge, Alcatraz, Angel Island, the Marin Headlands, and Tiburon and Sausalito beyond.

The Marina area has twice been destroyed and rebuilt after devastating earthquakes in 1906 and 1989 to remain an enduring and beautiful part of the city. At the east end is Fort Mason, a former army post that now hosts a Sunday farmers' market, regular gallery openings, creative and educational workshops, cultural events, and wine tastings. At the western edge, the Marina meets the rolling hills of the Presidio. Colonized by the Spanish in 1776 and once an active military base, the Presidio is now a fifteen-hundred-acre woodsy play area with parks and hiking trails, plus a few restaurants, a bowling alley, a golf course, a health spa, George Lucas's Industrial Light & Magic and LucasArts, and the wonderful Walt Disney Family Museum.

At the heart of the Marina District is Chestnut Street, popular with the younger crowds. Recent college grads from Stanford, Berkeley, and beyond flock to the Marina to hang out on Chestnut and Union Streets. Both streets are home to dozens of upscale boutique shops and eateries, and the bars overflow with the postgrad singles scene. A playground for the young and elite, the Marina has a rollicking vibe and is worth visiting for the energy and beautiful scenery.

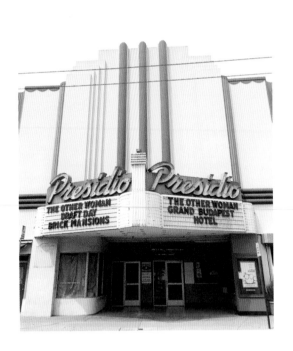

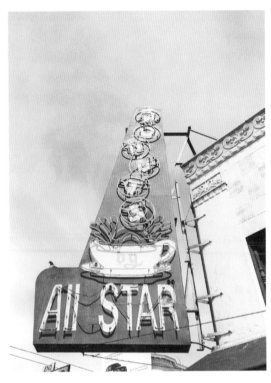

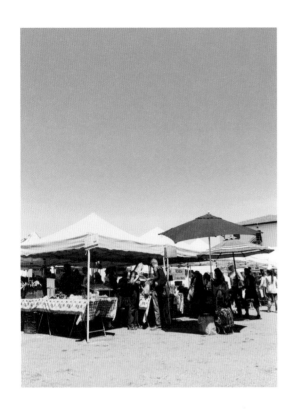

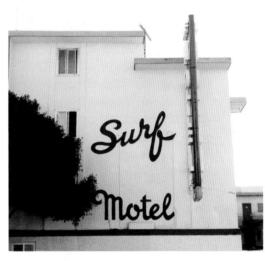

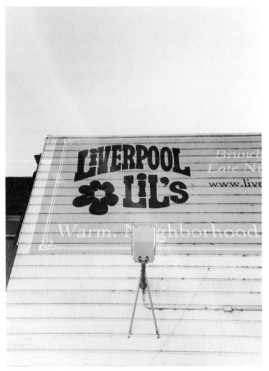

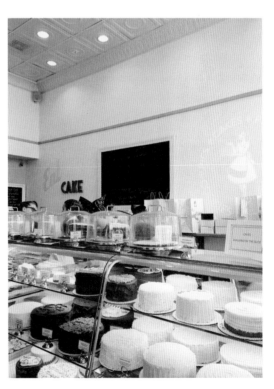

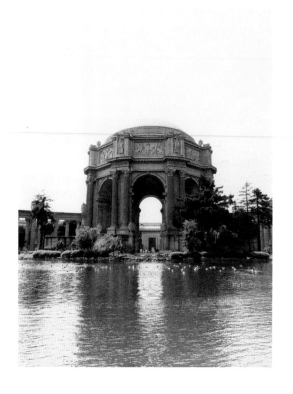

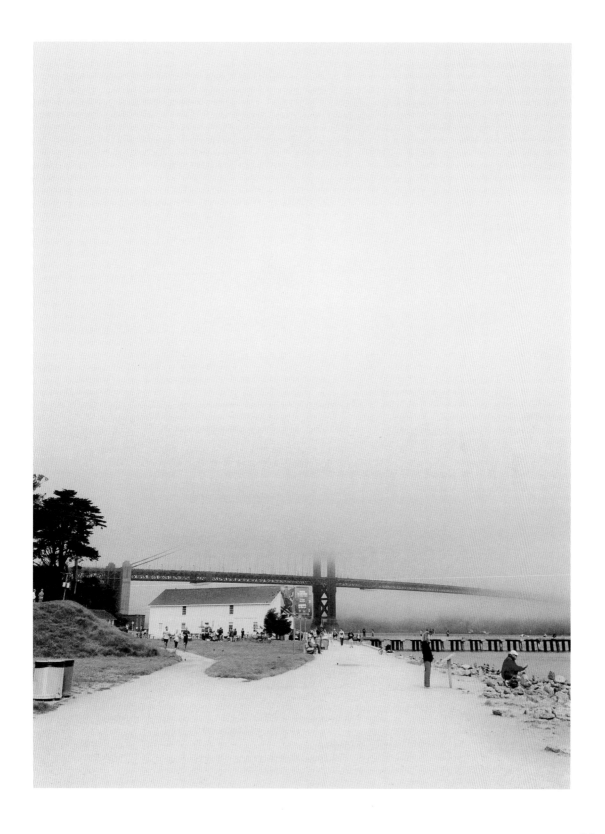

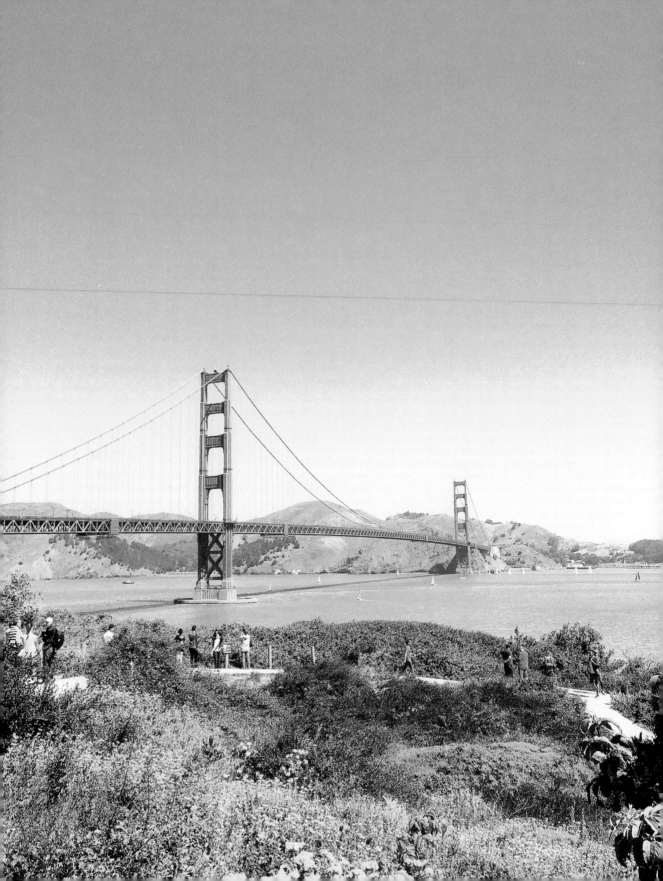

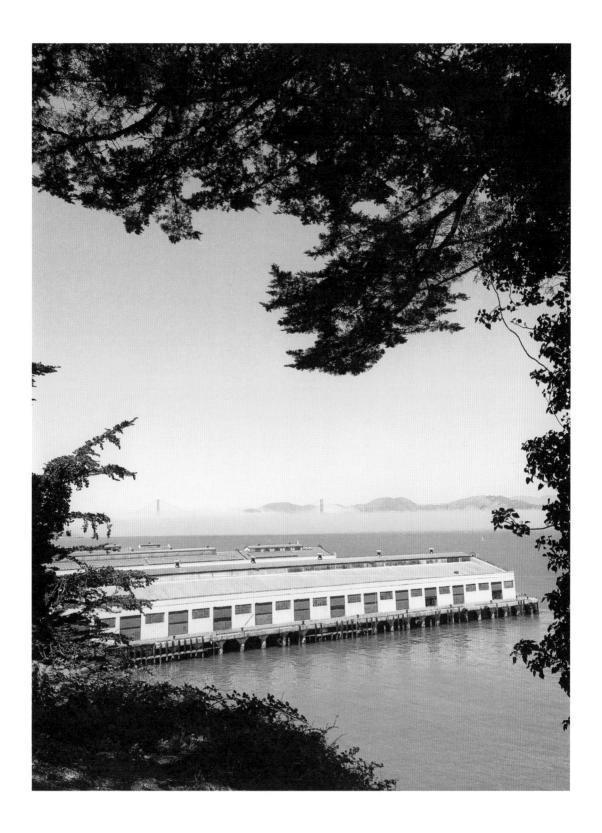

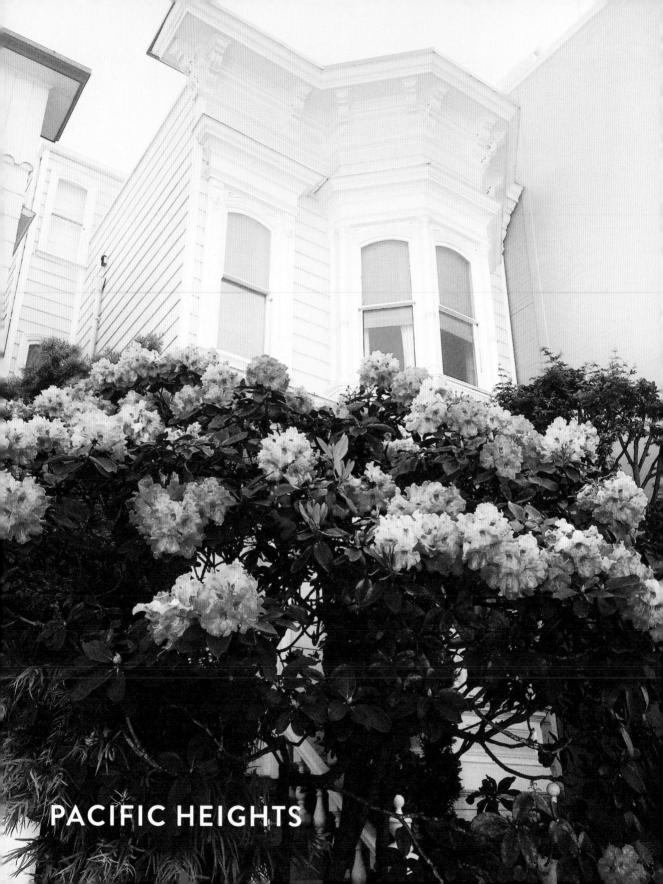

PACIFIC HEIGHTS

Pacific Heights is perched above the Marina on some of San Francisco's steepest hills. Built by the sugar tycoon Adolph Spreckels in 1912, the incredible Spreckels Mansion takes up an entire city block of Washington Street, snuggled behind ridiculously high hedges. The neighboring estates are also huge, with gorgeous architecture, well-manicured gardens, and unobstructed views of the Golden Gate Bridge and the Marin Headlands beyond.

When I lived here, I loved walking home through these quiet streets at night, peering perhaps a bit voyeuristically into the well-lit homes. I'm not sure what I hoped to see—maybe a Picasso hanging casually on a bedroom wall, or a well-dressed couple popping some fancy champagne.

Nestled among the stunning homes are several beautiful parks: the Presidio to the west and the hilltop parks Lafayette and Alta Plaza, both great public places to take in the pristine views. Every spring, some of San Francisco's finest interior designers occupy a local mansion for the San Francisco Decorator Showcase benefit, open to the public for a small charitable fee, which is a great way to tour one of these homes from the inside out.

Atop one of Pacific Heights' highest hills in the center of the neighborhood is the northern portion of Fillmore Street, which offers rows of posh shops, primarily upscale women's clothing boutiques and luxurious home-goods stores. There are some wonderful places to eat, too, such as the teeny-tiny Jackson Fillmore, probably my favorite Italian restaurant in the city. The Clay, with its iconic neon marquee, is one of the few remaining vintage theaters in the city and a wonderful spot to catch an afternoon matinee.

From Jackson Street all the way down to Bush Street, Fillmore Street is filled with outdoor cafés. It's a great place to spend a leisurely sunny afternoon.

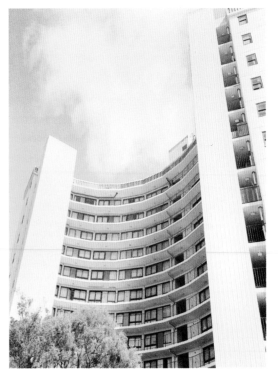

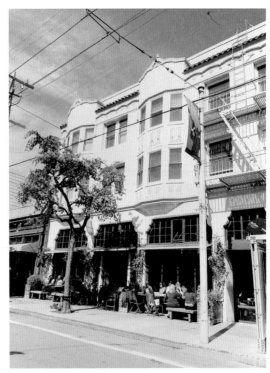

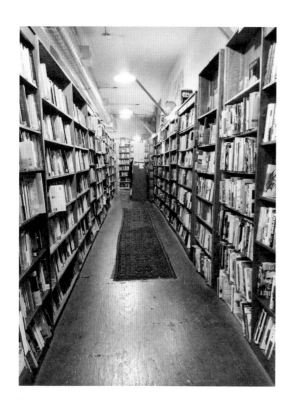

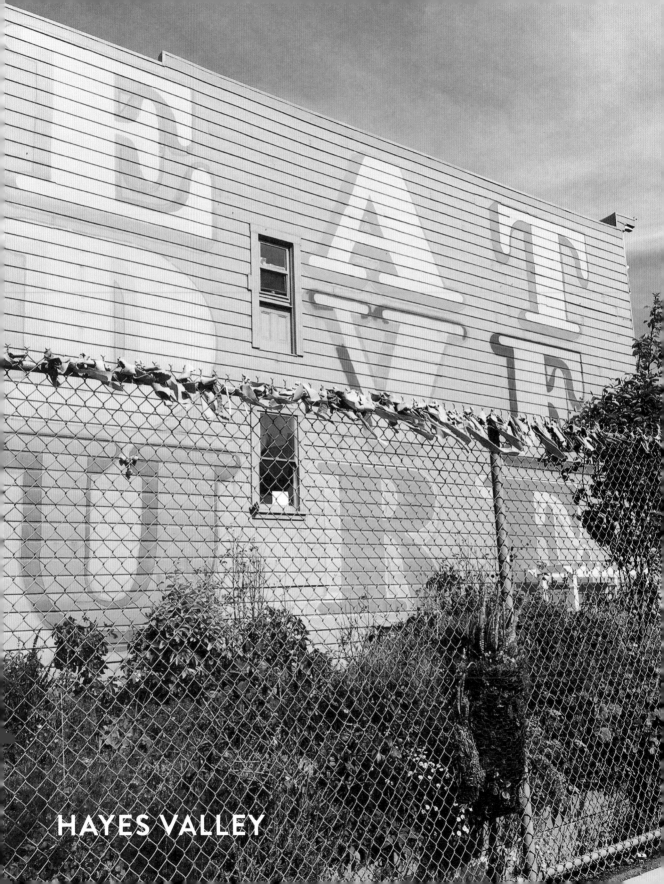

HAYES VALLEY

Hayes Valley is virtually unrecognizable from what it was ten years ago, when it had a freeway running through it. Now, that highway is long gone, and in its place is a bustling, hip, and entrepreneurial community bent on innovation. Baristas meticulously brew some very serious coffee by the cup in converted shipping containers, while down the block, ice cream is made one cone at a time using a high-tech liquid nitrogen contraption. A beer garden in a former parking lot serves up tall, cold steins with warm pretzels; it even has Pendleton blankets to wrap up in if you get chilly while you sit and sip.

This neighborhood has been gentrified rapidly, and the change hasn't come without controversy. On the upside, Hayes Valley has a strong sense of community and culture. There's a beautiful children's playground and picnic area in what was once a freeway on-ramp, and businesses are thriving.

The performing arts district runs along the northern edge of the neighborhood and includes Davies Symphony Hall, the War Memorial Opera House, the new SFJAZZ Center, and the restored Nourse Theater.

Hayes Valley has a renewed vitality, one that is typically San Franciscan. Walking through these streets, you can sense a collective motivation to live a cultured and meaningful life.

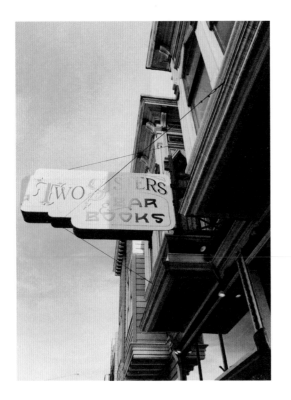

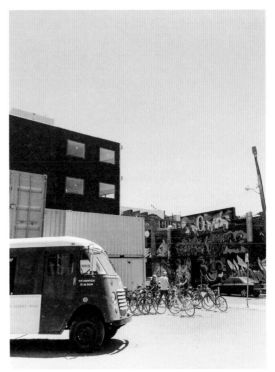

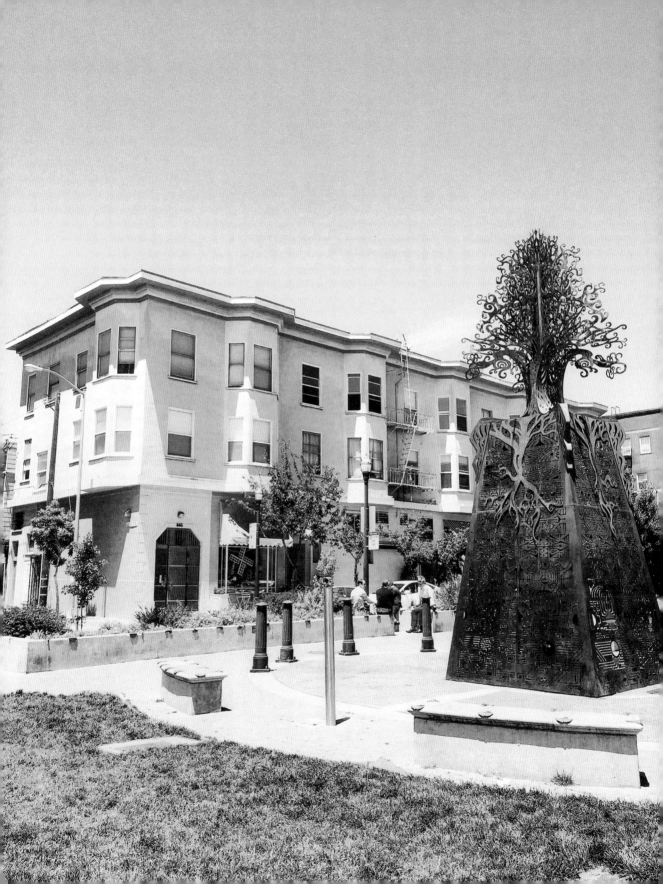

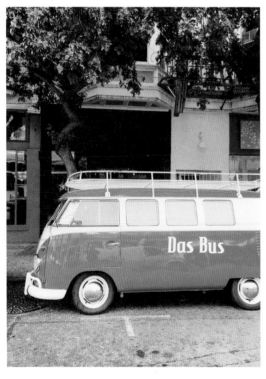

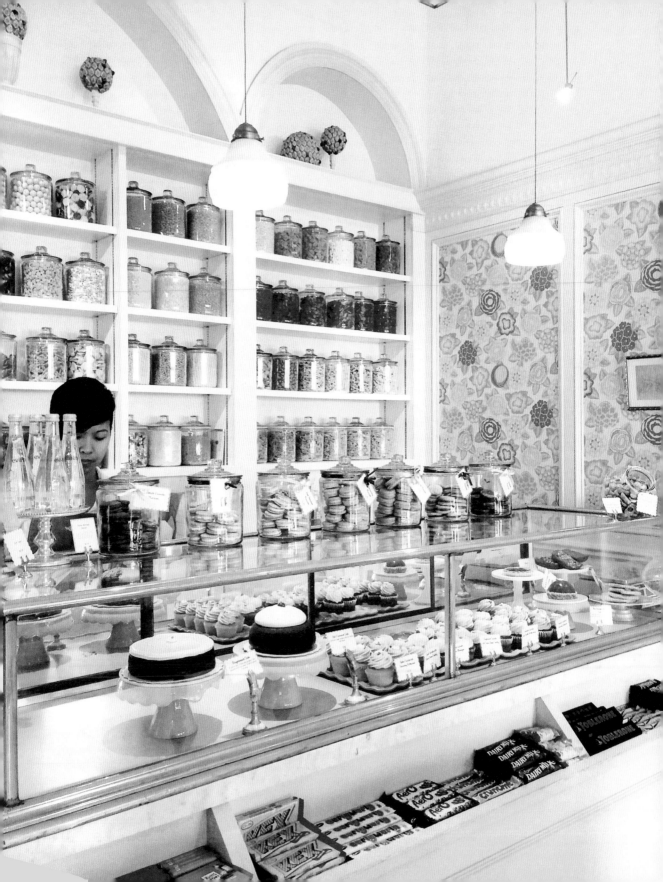

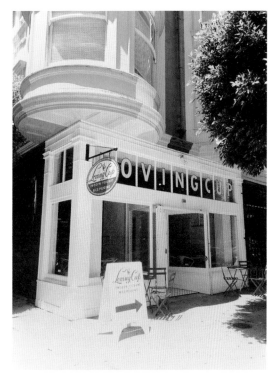

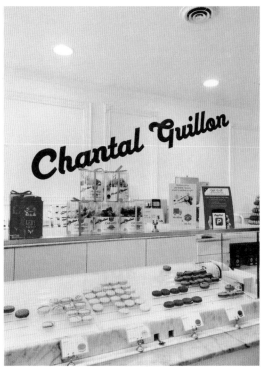

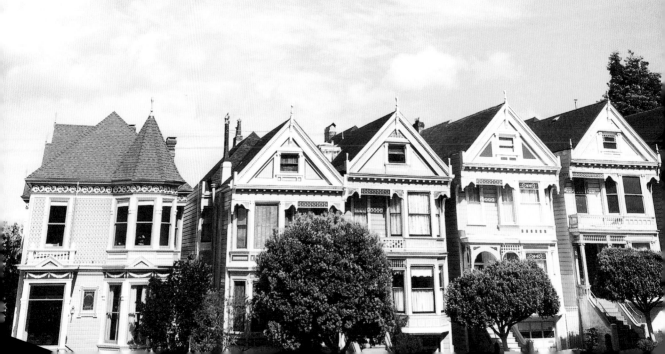

The Western Addition is one of the city's most multicultural and historical neighborhoods. The area was damaged by the 1906 earthquake and ensuing fires, and still boasts some of the most architecturally ornate and stunning homes in the city. It also boasts one of the most photographed spots in San Francisco: the Painted Ladies, the row of restored Victorian homes along Steiner Street and Alamo Square Park. You'll recognize the spot by the gaggle of tourists photographing these postcard-perfect homes from the grassy hillside across the street.

The Western Addition is *the* place to go for music in the city. East of Alamo Square is the Fillmore District, home to some great jazz clubs and the famous Fillmore, known for its sold-out concerts produced by legends like Bill Graham, who introduced audiences to musical greats such as Jimi Hendrix and the Grateful Dead.

Spread across a few blocks nearby is Japantown, a small, Mid-Century-Modern-looking mall. This has some of the best sushi in town, vibrant Japanese markets, and one of my favorite bookstores, as well as the recently refurbished Kabuki Theater, owned by Robert Redford's Sundance group. If you should happen to find yourself here in April, be sure to stay for the Cherry Blossom Festival to ogle the blooms. It is the prettiest and best time to walk around Japantown and celebrate Japanese-American culture in the city.

Recently, the southern portion of the Western Addition has become identified as NOPA, for "North of the Panhandle," the long narrow extension of Golden Gate Park shaped like a panhandle that runs through this part of the city. At the end of the panhandle, east of the park, is Divisadero Street, a busy area with an ever-evolving crop of new shops and restaurants. One of the city's best gourmet markets has opened its doors here, and lots of small independent designers and boutiques have popped up among the bars and music clubs. The Independent is a main attraction of the neighborhood and continues to present an impressive lineup of live shows.

Just east of Divisadero to Webster Street is the Lower Haight, sometimes referred to as Haight-Fillmore, where a few blocks along Haight Street have a kind of postpunk, countercultural atmosphere. This small stretch is still pretty ungentrified and is bustling with artsy, eclectic boutiques and cafés, mostly frequented by a younger crowd who keep the small nightclubs and bars packed until closing.

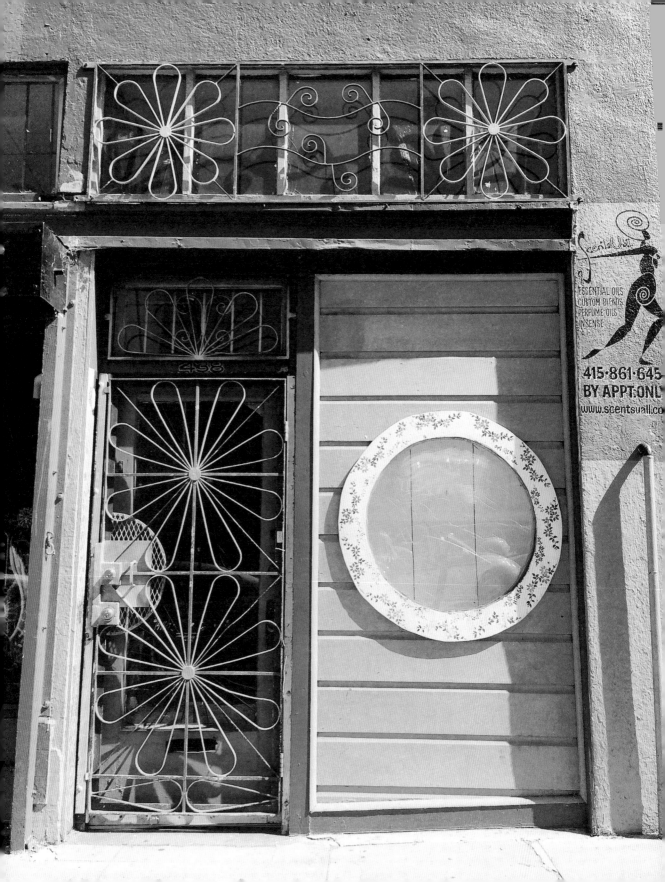

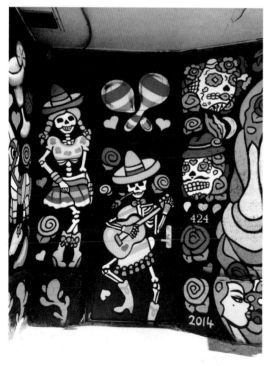

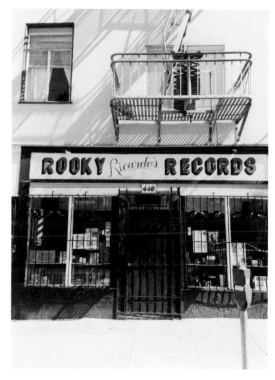

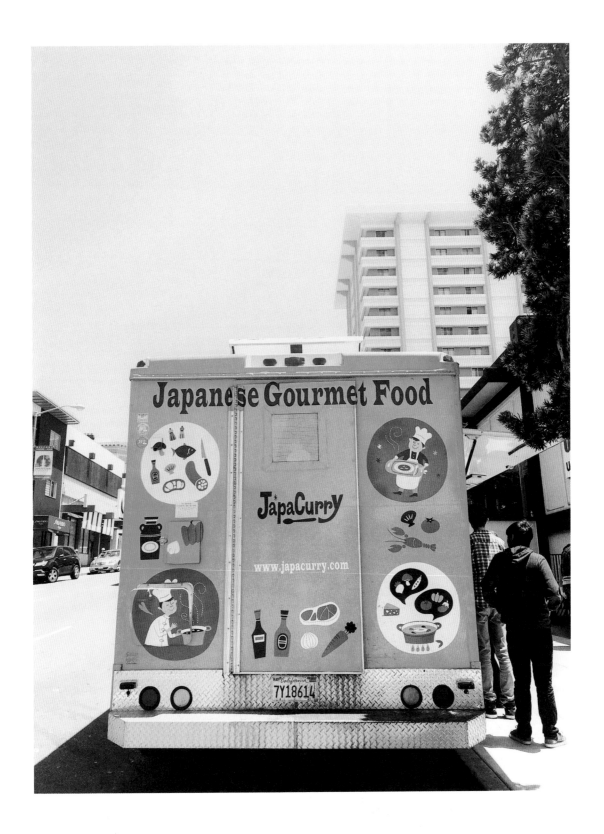

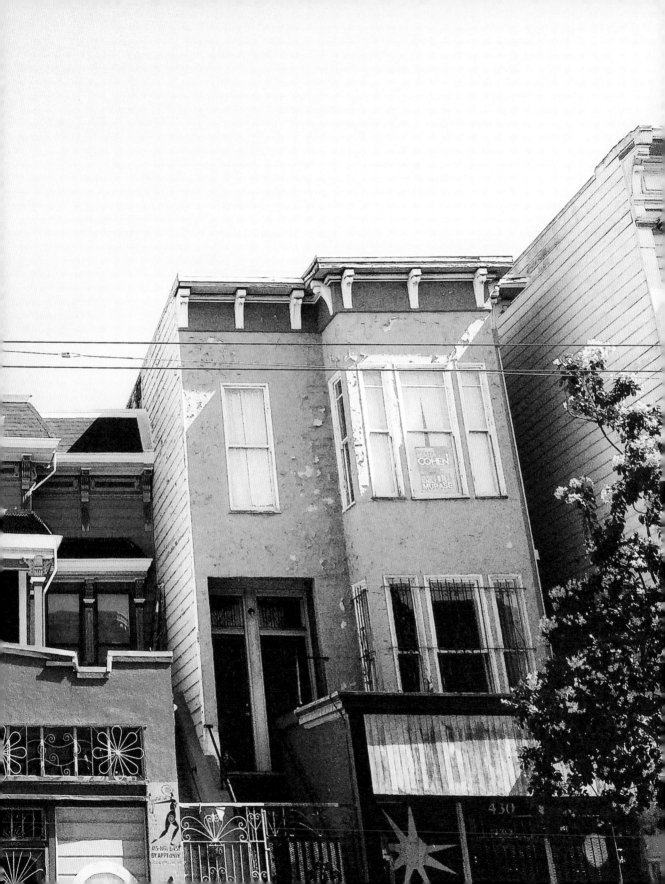

FAMILY MATINEE:
MULAN
BORN TO FLY

Looking east across the city from the top of Twin Peaks and Sutro Tower, you can spot a huge rainbow-striped flag flapping steadily in the breezes that blow up Market Street from the bay. The flag symbolizes gay pride, and the streets below are as colorful as the flag itself. This is the Castro District, where gay and lesbian residents founded a new community and welcomed others with open arms; where, in 1977, Harvey Milk became the first openly gay person to be elected to public office in California.

It's no secret that San Francisco is a liberal city at heart, and the Castro may well be the most liberal of all of its neighborhoods. You may, for instance, find yourself sharing a bench with a few well-tanned and weathered naked fellows. Don't be alarmed—just remind yourself you're in the Castro, and admire their bravado. It's not everyone who can sit naked in public while casually eating a crème brûlée from the nearby pop-up cart. But in the Castro, that's how it's done.

Mind you, the general population is actually very well-dressed. It's a stylish and desirable neighborhood, with manicured Victorians painted an array of bold shades perched on the hilly enclaves surrounding Castro Street. The café lifestyle is embraced here, and you'll find lots of little restaurants with outdoor seating.

There's a lot to see in this neighborhood, including a wonderful weeknight farmers' market, a great used-record store, and the Castro Theatre with its huge neon marquee, an iconic Castro landmark. The theater shows classics like *Valley of the Dolls* and hosts sing-along nights with movies including *Mary Poppins* and *West Side Story*. Locals and visitors revel in this playful enthusiasm for theatrical drama, an energy that spreads through the rest of the neighborhood.

The Castro District is the kind of place where anything goes. You'll have the best time if you just go along with it.

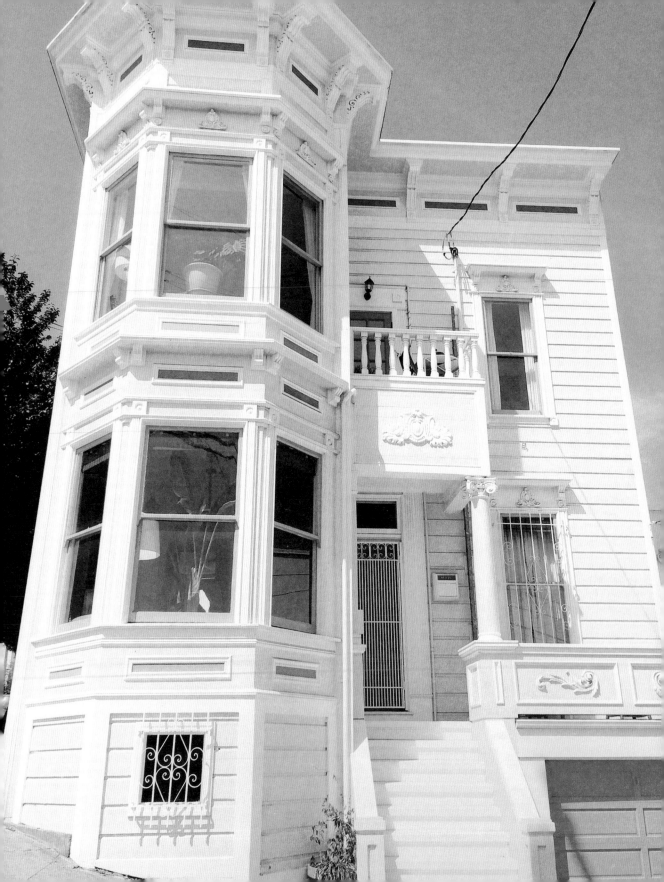

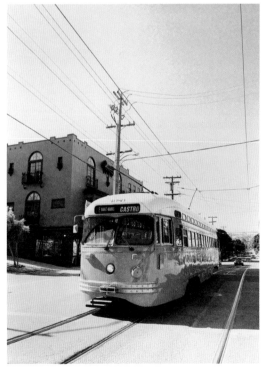

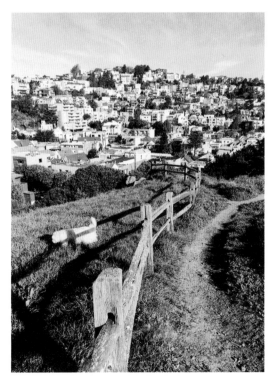

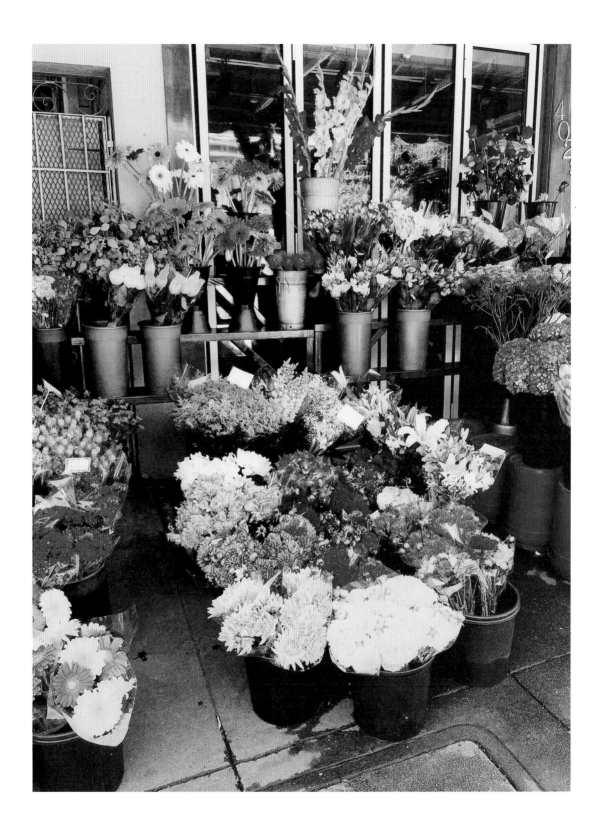

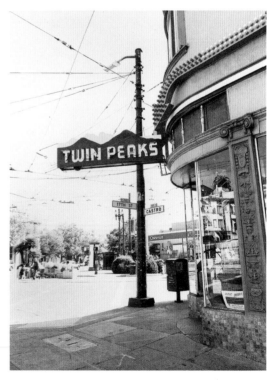

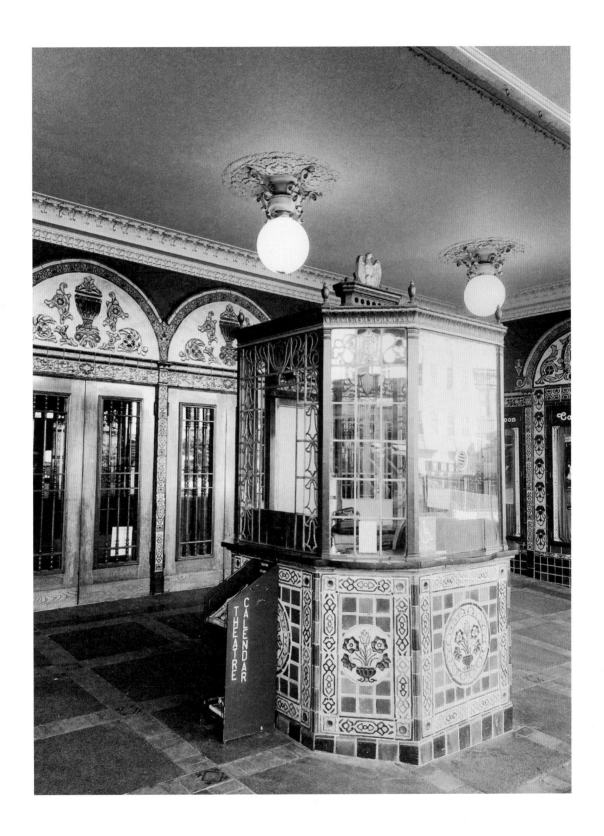

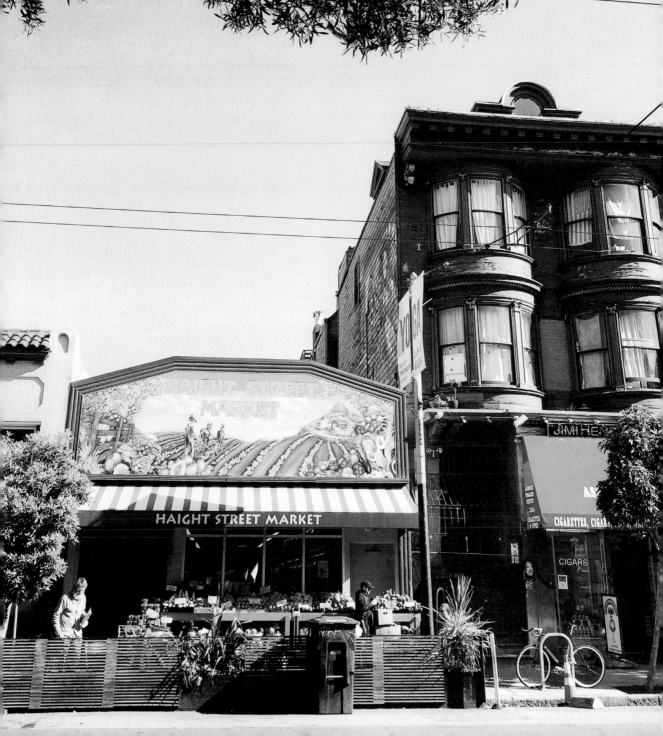

Haight-Ashbury is the most iconic neighborhood in San Francisco, the eccentric heart of the city. Called "the Haight" by locals, it is synonymous with the era of free love and hippies. Musicians and bands like Janis Joplin and Jefferson Airplane famously got their start in the Haight, playing concerts in Golden Gate Park, and it remains a liberal and unconventional place.

Street corners are filled with pierced and tattooed young people. The smell of incense wafts out of the head shops that pepper the street. Tourists flock to the neighborhood to take pictures in front of the Haight-Ashbury street sign and grab ice cream from Ben & Jerry's on the famous corner.

The Haight has a ton of vintage and secondhand clothing shops and plenty of alternative bars and nightclubs. The crowd is colorful, from the street kids to the twentysomethings who shop and club here to the original hippies who still call this neighborhood home.

Up the hill from Haight Street is an urban forest called Buena Vista Park with wooded trails and stunning vistas. Surrounding the park is Ashbury Heights, home to some of the most beautiful and ornate Victorians in the city, which line steep streets with picturesque views at every turn.

Tucked between the hills is Cole Valley, a tiny offshoot of the Haight with its own distinctive, quieter vibe. It is just a few charming blocks, but manages to contain one of the city's best hardware stores, some great coffee shops, and a cozy old bar, the Kezar, dating back to the early twentieth century, when the area was still mostly dairy farms.

To the west, where Haight Street meets Stanyan Street, is the entrance to the city's glorious "outer lands," Golden Gate Park. Just inside the park is Hippie Hill, where you'll find characters hanging out in tie-dye and army-green fatigues, a throwback to the hazy-lazy love-ins the park was so famous for in the late '60s.

The park stretches from Stanyan Street in the Haight three miles west to Ocean Beach, and within those green acres (which were once sand dunes!) are lush walking trails, bike rentals, lakes, botanical gardens, and two major museums, the de Young and the California Academy of Sciences, both known as much for their exhibits as their unique architecture.

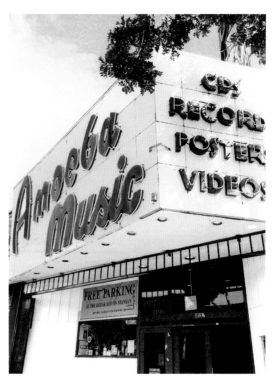

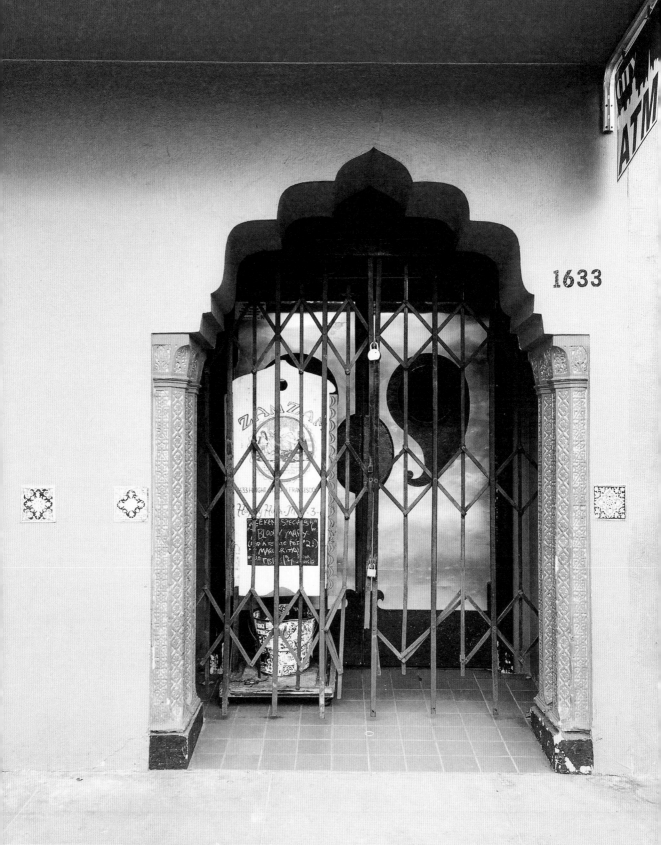

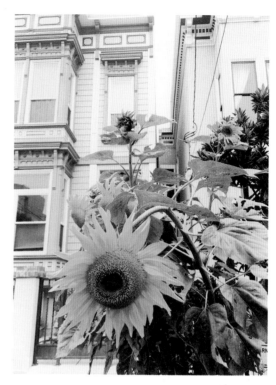

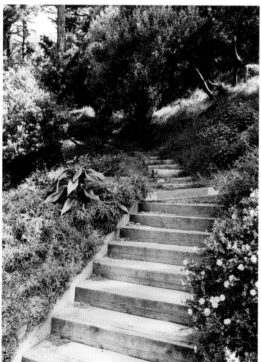

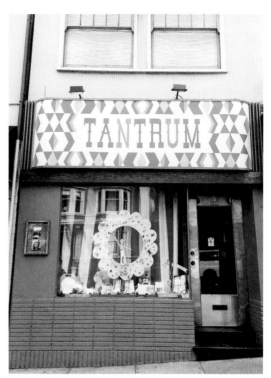

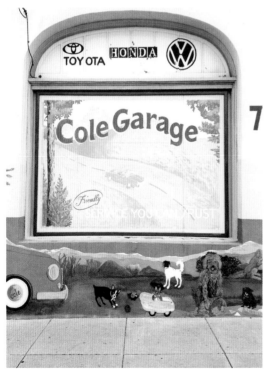

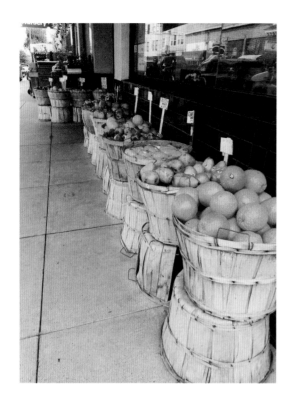

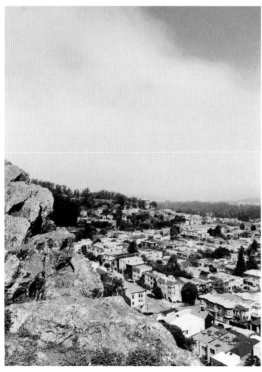

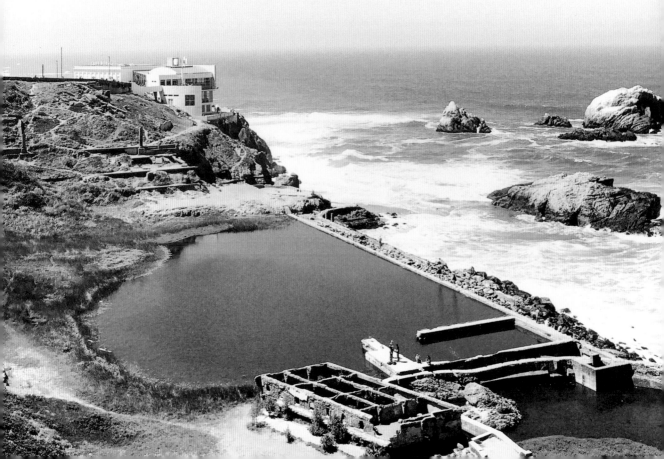

The Richmond District ("the Richmond" to locals, not to be confused with the city of Richmond in the East Bay) was first called "The Outside Lands" because it was outside city boundaries when California became a state. Running along the north side of Golden Gate Park and out to the ocean, it wasn't officially made part of San Francisco until 1866. Now there is an annual summer music festival that tips a cap to the neighborhood's past with its name, Outside Lands, and fills Golden Gate Park with dozens of indie bands and thousands of music lovers.

The Richmond is full of parkland: Golden Gate Park makes up the southern border, with the Presidio and Lands End to the north, and Lincoln Park and the Pacific Ocean to the west. There are beautiful sandy beaches, too—China Beach and Baker Beach—that are rarely sunny but have stunning views.

This is a richly historic part of the city where San Franciscans once spent their leisure time. In the late nineteenth and early twentieth centuries, the Sutro Baths and the Cliff House restaurant drew thousands of visitors. The Cliff House is still there; while a tad touristy, it is a beautiful spot to enjoy a cocktail or a meal overlooking the ocean. The Sutro Baths were once a huge indoor public bathhouse perched above the cliffs of the Pacific, accommodating thousands of people at one time. Just the mossy ruins remain now, providing some cool exploring. I like to imagine what it was like when the baths were in full swing. One of the prettiest ways to get to this area is to hike the Lands End Coastal Trail, which begins at the edge of the Presidio Golf Course and ends at the Sutro Baths and the Lands End Lookout.

Like the Sunset District, this neighborhood is split into outer and inner sections, divided by Park Presidio Boulevard. The Outer Richmond is mostly residential and quiet, with a large Russian population, while the Inner Richmond is livelier, with delicious East Asian restaurants running along Clement Street. I come here for some of the cheapest produce in the city and to pick up unusual odds and ends like Fourth of July sparklers, spices, and chopsticks in bulk.

Perhaps one of Clement Street's most popular spots is Green Apple Books, whose terrific selection of new and used books overflows onto the street. The strip of Clement Street from Arguello Boulevard to 6th Avenue has a few new boutiques, a gallery, and some great vintage shops.

There is a lot to see in the Inner Richmond, so I highly recommend exploring it on foot so you can roam in and out of the shops, grab some dim sum to go, and see all the neighborhood has to offer (plus, the parking here is legendarily difficult).

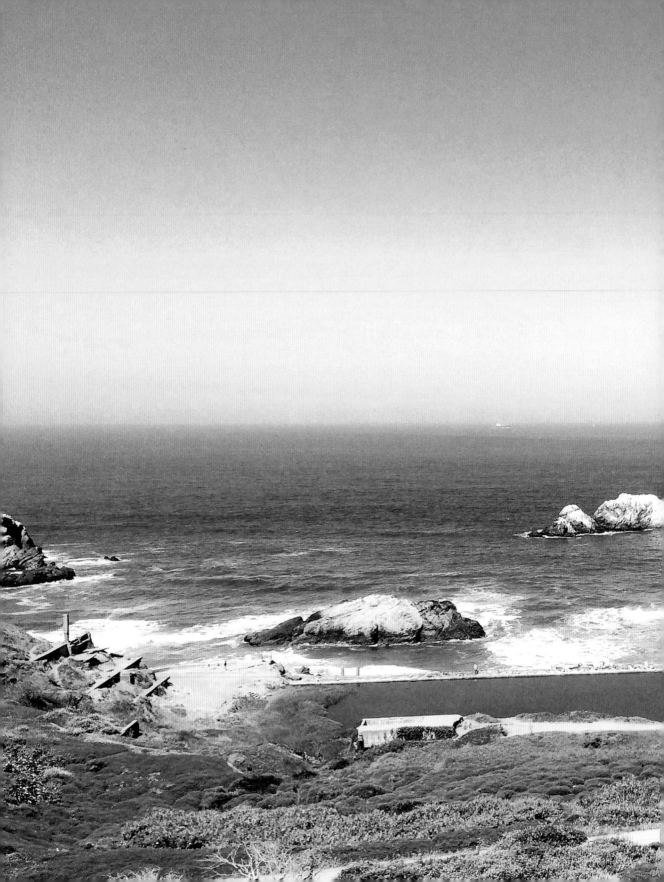

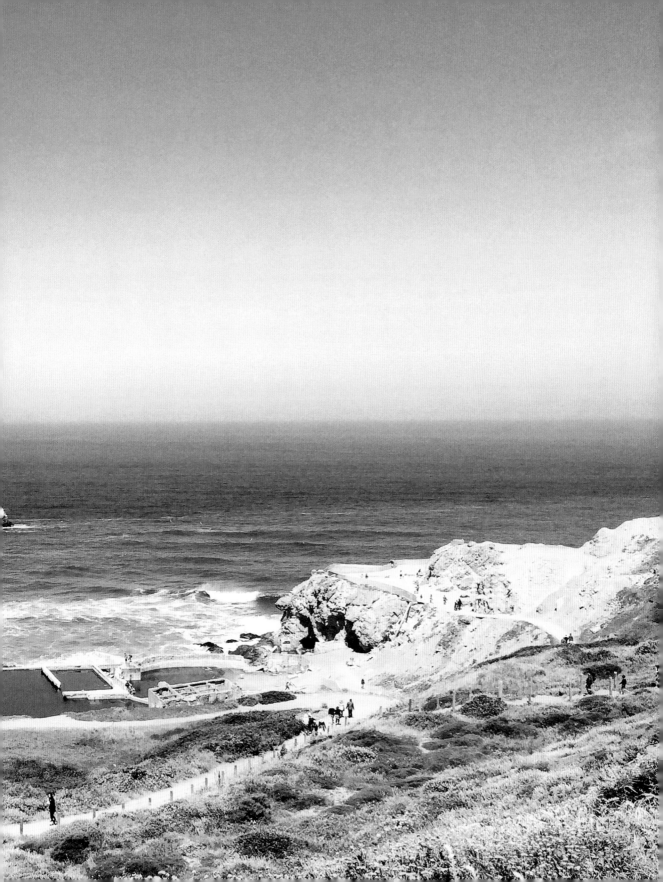

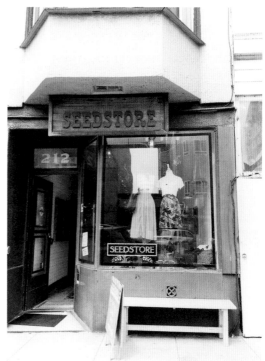

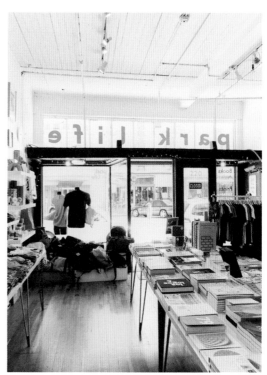

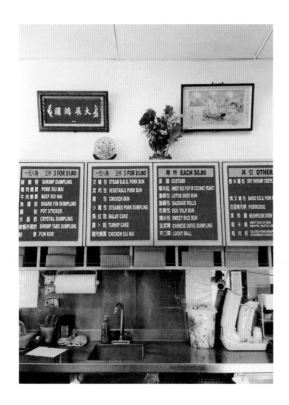

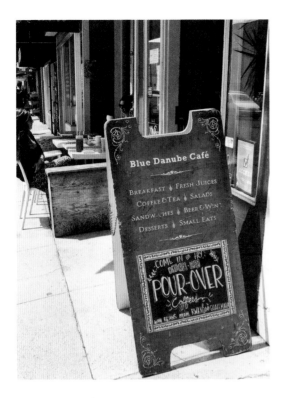

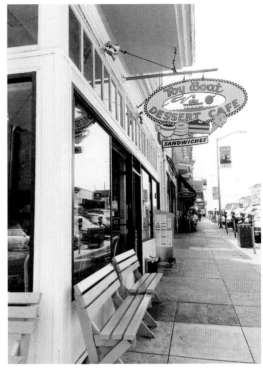

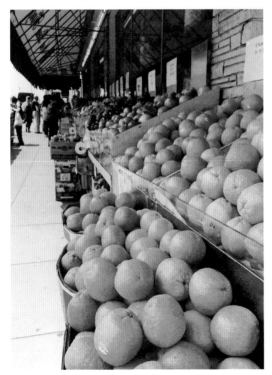

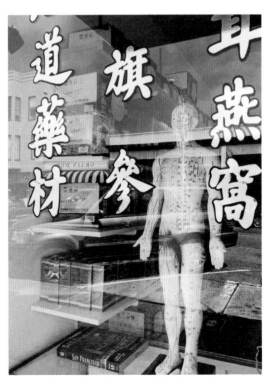

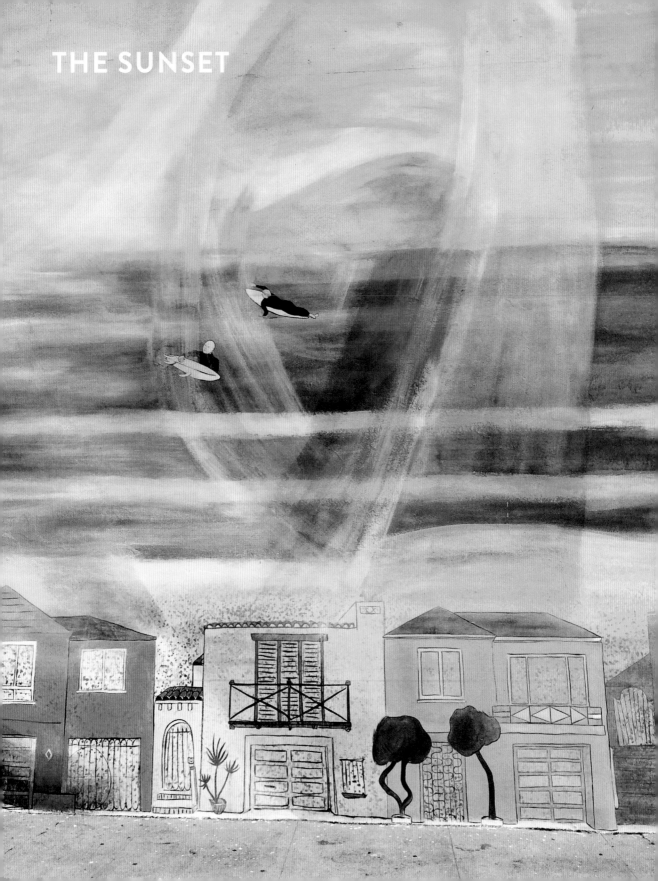

The irony of the Sunset's name is probably not lost on its residents, for this neighborhood is one of San Francisco's foggiest. Residents rarely see the sun, let alone an actual sunset! But when sunshine does arrive, and honestly even when it doesn't, it is one of my favorite places to explore.

Until the 1930s and even late 1950s, vast swaths of the Sunset District were still covered in sand dunes, and the area was quite remote—making living here impractical. It wasn't until the streetcars arrived, making a commute possible, that San Franciscans started purchasing land and building homes here, and the Sunset saw growth and became an affordable, livable neighborhood.

The Sunset runs parallel along the southern edge of Golden Gate Park. It is divided into two microhoods: the Inner and Outer Sunset. Each has its own flavor, and both have great proximity to nature.

The Outer Sunset, closest to the Pacific coast, is like a small and charming beach town. Along Judah Street right off Ocean Beach, you'll find surf shops, artist studios, tiny boutiques, and quaint breakfast spots where you're likely to spot local surfers just out of the waves. By the way people greet each other, it seems like everyone knows each other, and you can tell it's a friendly, close-knit, and quiet community.

One of my favorite places just south of the Sunset is Fort Funston. Once a military lookout, it's now part of the Golden Gate National Recreation Area, with stunning vistas overlooking the Pacific and some of the prettiest off-leash wooded hiking trails to stroll with your dog or friend.

The Inner Sunset's proximity to Golden Gate Park and its best-loved destinations—Stow Lake, the California Academy of Sciences, the de Young Museum, the Japanese Tea Garden, and the San Francisco Botanical Garden—make it a popular neighborhood to dine in. The neighborhood becomes a bit livelier around the area of 9th Avenue and Irving Street, where you'll find delicious ethnic eats—including handmade Chinese noodles and some of the city's best sushi—as well as a lively pub crowd. The University of California San Francisco campus is here, so you can find less expensive bars and restaurants that cater to the student community.

Say what you will about the ever-present mist and fog, the Sunset neighborhoods are some of the city's best. All you need are a few warm layers and a good appetite.

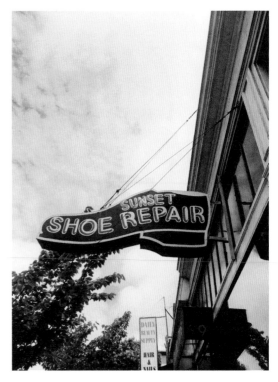

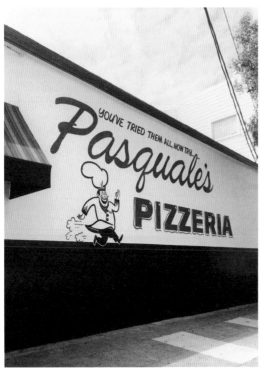

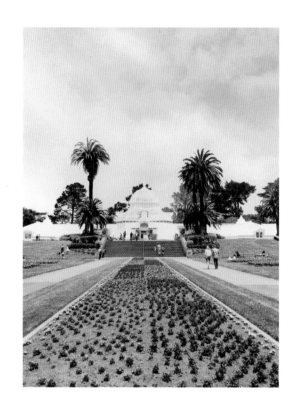

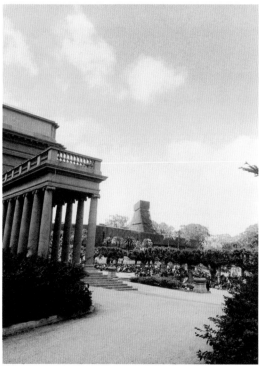

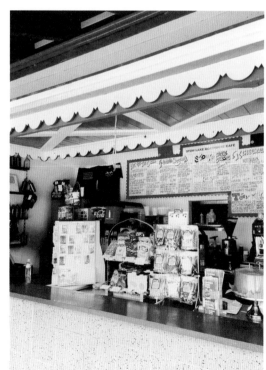

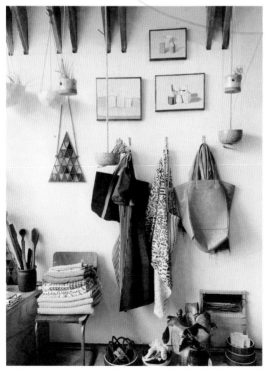

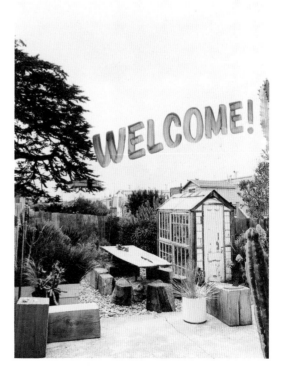

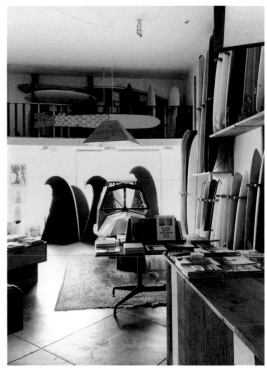

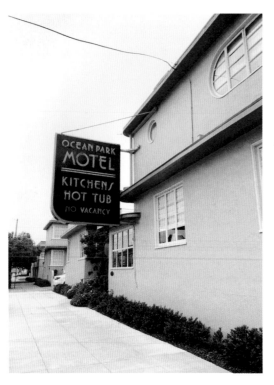

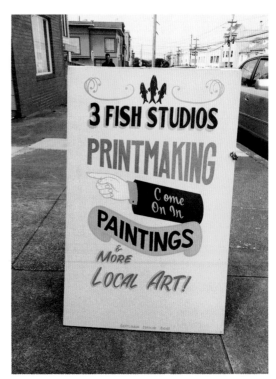

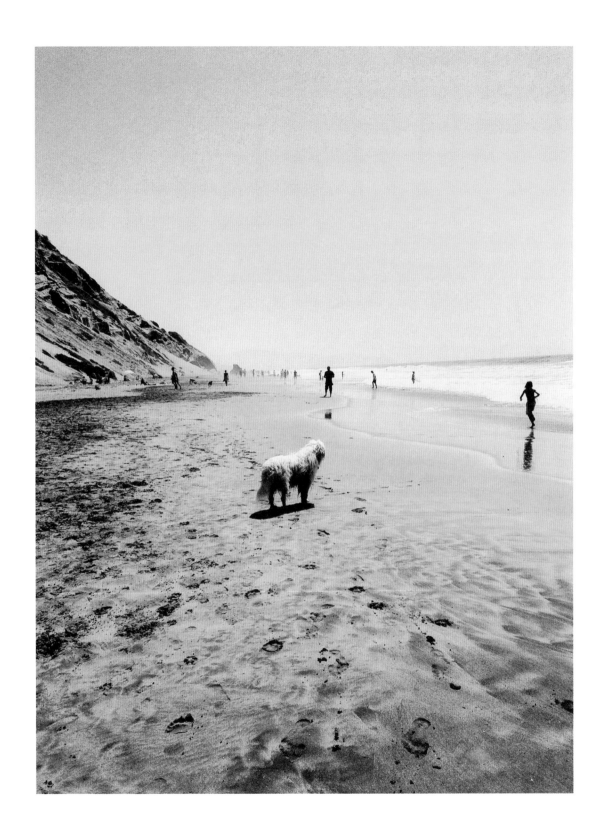

VICTORIA'S FAVORITES

For more favorites, visit www.sfgirlbybay.com

Billy Goat Hill

With some of the most amazing views of the bay and the city, Billy Goat Hill is one of San Francisco's thirty-one Natural Areas dedicated to preserving its variety of beautiful native flora and fauna. The tree swing at the top of the hill is a must-try if you want to feel like a kid again. You can access Billy Goat Hill from both 30th and Beacon Streets.

300 Beacon Street
sfrecpark.org/destination/billy-goat-hill

Glen Canyon Park

Glen Canyon Park includes seventy acres of parkland, giving you a peek into the terrain that existed before the city of San Francisco was developed. While owls and red-tailed hawks fly about, wander Glen Canyon's network of trails and meander along the pretty stream that runs through it.

Elk and Chenery Streets
415-831-6300
sfrecpark.org/venue/glen-canyon-park

Harry Street Stairs

Climb up (or down) these 250 wooden steps from Laidley to Beacon Street and you'll discover quaint cottages tucked away in secret overgrown and lush gardens. I love this hidden staircase in the middle of a big city.

Harry Street, between Laidley and Beacon Streets

Noe Valley Farmers' Market

Run largely by community volunteers, the Noe Valley Farmers' Market showcases a lovely selection of organic produce, live music, and neighborhood friendliness on Saturdays year-round. Stop by on the earlier end if you can—this is a busy spot and many vendors run out of popular items early.

3861 24th Street
415-248-1332

BERNAL HEIGHTS

Alemany Flea Market

The Alemany Flea Market is held every Sunday, rain or shine. Even if you don't find a vintage treasure, it's a free day of entertainment because there's no cover charge.

100 Alemany Blvd
415-647-2043
sfgsa.org/index.aspx?page=1059

Bernal Heights Summit

Also known as Bernal Heights Hill, Bernal Heights Summit is one of the highest points in the neighborhood. A wonderful off-leash park to take your dog with 360-degree views of the entire city, it's especially lovely in the spring when native wildflowers of all kinds are in bloom.

Bernal Heights Boulevard
sfrecpark.org/destination/bernal-heights-park

Mitchell's Ice Cream

Every single option at Mitchell's—with small-batch flavors like avocado, halo halo, and jackfruit—looks like the creamiest, tastiest scoop of ice cream you'll meet. Mitchell's has an old-fashioned feeling, with families lined up out the door on warm San Francisco days.

688 San Jose Avenue
415-648-2300
www.mitchellsicecream.com

Precita Park

This is a great spot to picnic with kids, play with your dog, or just lounge outside with a good book, surrounded by cafés (Precita Park Café), restaurants (Hillside Supper Club), and Harvest Market if you get hungry.

Precita Avenue and Folsom Street
415-695-5051
sfrecpark.org/destination/precita-park

THE MISSION

Bi-Rite Creamery

If you're looking to spoil your belly silly, this is the ice cream shop to hit. Look for the really long line around the block—it's worth the wait for gourmet flavors like salted caramel and balsamic strawberry.

3692 18th Street
415-626-5600
biritecreamery.com

826 Valencia

Founded by local author Dave Eggers, this "pirate shop" is dedicated to tutoring and creative writing workshops for children. You'll find it stocked with eye patches, spyglasses, and some incredibly helpful pirate guides—all designed to spark the imagination of the students.

826 Valencia Street
415-642-5905
www.826valencia.org/store

Foreign Cinema

One of my favorite spots in the Mission, Foreign Cinema serves up craft cocktails and a Mediterranean-inspired menu with a California spin, all while screening foreign and indie films in a gorgeous outdoor courtyard space strung with tiny globe lights, making the dining experience that much more magical.

2534 Mission Street
415-648-7600
www.foreigncinema.com

Mission Dolores Park

By far one of the most popular San Francisco parks, Dolores Park is a fun place to spend a warm afternoon people watching and sun worshipping with great views of the city. It offers luscious green grass, tennis and basketball courts, playgrounds, a dog run, and more in the middle of this very vibrant Mission neighborhood.

19th and Dolores Streets
415-554-9521
sfrecpark.org/destination/mission-dolores-park

La Taqueria

La Taqueria is an unassuming spot in the heart of the Mission, where rave reviews of the carnitas burritos keep customers coming back for more.

2889 Mission Street
415-285-7117

POTRERO HILL AND DOGPATCH

Farley's

Created by Roger Hillyard in 1989 as a coffee and tea store and place of community for the neighborhood, Farley's mission to create "a human space," where everyone is welcome and comfortable, remains to this day. It also hosts one of the best selections of magazines in the city.

1315 18th Street
415-648-1545
www.farleyscoffee.com

Heath Ceramics

Making beautiful ceramic tableware in the Bay Area since 1948, Heath now has storefronts in the Ferry Building and Potrero Hill.

2900 18th Street
415-361-5552
www.heathceramics.com

Serpentine

A favorite weekend brunch spot for Dogpatch locals, Serpentine serves up local and sustainable dishes for breakfast, lunch, dinner, and cocktail hours in an industrial yet friendly atmosphere. Some of the best burgers in town!

> 2495 3rd Street
> 415-252-2000
> www.serpentinesf.com

SOMA

Flora Grubb Gardens

Far South of Market in the Bayview area, this stunning nursery is a mix of eco-friendly plants that don't require mass quantities of precious water, alongside some pretty cool furniture finds. It serves up Ritual Coffee, and there's a cozy little patio out back.

> 1634 Jerrold Avenue
> 415-626-7256
> www.floragrubb.com

MUJI

Japanese brand MUJI's first West Coast store showcases simple, pretty clothes and a huge, seven-thousand-square-foot selection of utility-minded and unusual housewares at great prices. MUJI aspires to offer simple yet thoughtfully designed products. If you're a fan of the Japanese aesthetic of "less is more," this is a must-visit.

> 540 9th Street
> 415-694-5981
> www.muji.us

San Francisco Flower Mart

My go-to stop for the freshest flowers, the San Francisco Flower Mart is affordable and open to the public. You can find the most interesting selection of branches and blooms, sourced locally and internationally, to create your own unique bouquets.

> 640 Brannan Street
> 415-392-7944
> sfflowermart.com

Book Passage

Book Passage is one of my favorite bookshops for readings, writing workshops, and events. The Ferry Building location can't be beat for the view of the bay and vicinity to lovely shops and markets. Shop for a new cookbook and then hit the farmer's market for your ingredients—a perfect day!

> 1 Ferry Building
> 415-835-1020
> www.bookpassage.com

Britex Fabrics

A San Francisco Union Square landmark, Britex Fabrics is a must-visit for designers, sewers, DIYers, and anyone seeking creative inspiration. It offers three huge floors of sewing heaven and features a unique selection of fabrics, buttons, ribbons, and lace trims.

> 146 Geary Street
> 415-392-2910
> www.britexfabrics.com

Ferry Building Marketplace

This is a fun place to check out on weekdays for regulars like Heath Ceramics and Cowgirl Creamery, or on weekends for the Ferry Building Farmers' Market with its bustling, colorful array of locally grown produce, food tents, and bright fresh flowers.

> 1 Ferry Building
> 415-983-8030
> www.ferrybuildingmarketplace.com

Red's Java House

Located just beneath the Bay Bridge on the Embarcadero, this is one of the city's classic dives. Come for a double cheeseburger, a beer, and perfect views of the bay.

> Pier 30
> 415-777-5626
> www.redsjavahouse.com

NORTH BEACH

Al's Attire

A somewhat secret San Francisco institution, Al's is tucked away on Grant, a tiny back alley of a street in North Beach. Al is a tailor to the untrendy but well-heeled fashionistas by the bay. If you're looking for a classic vintage coat or a special custom-made suit, or if you simply need to tailor your wardrobe, this is the place to come.

> 1300 Grant Avenue
> 415-693-9900
> *alsattire.com*

City Lights Bookstore

City Lights is a landmark of the Beat culture, a three-story independent bookshop that's been a "Literary Meeting Place since 1953," and once the frequent hangout for Beat authors like Jack Kerouac and Allen Ginsberg.

> 261 Columbus Avenue
> 415-362-8193
> *www.citylights.com*

Coit Tower

A well-spotted city landmark, Coit Tower is an art deco-style tower made of reinforced concrete atop Pioneer Park on Telegraph Hill, funded by and erected in honor of eccentric heiress and volunteer firefighter Lillie Hitchcock Coit. You can drive up to the tower or climb the many steps of the hill to tour its interior murals and take in the view of the city from this well-known monument.

> 1 Telegraph Hill Boulevard
> 415-249-0995
> *sfrecpark.org/destination*
> */telegraph-hill-pioneer-park/coit-tower*

Vesuvio Café

Vesuvio is a quirky, eclectic spot to stop in for a quick drink or to take in the funky ambience over a book at the bar. Just across from the famous City Lights Bookstore, it's known for being a regular hangout of the late Jack Kerouac and other Beat pioneers of the '60s.

> 255 Columbus Avenue
> 415-362-3370
> *www.vesuvio.com*

CHINATOWN

Golden Gate Fortune Cookie Factory

Tucked into the unassuming Ross Alley, this is the source of the sweet fortune cookie aroma wafting through the streets of Chinatown. Step inside to see these tiny secrets being wrapped right in front of you, and grab a bag to snack on as you make your way through the rest of the sights.

> 56 Ross Alley
> 415-781-3956
> *www.sanfranciscochinatown.com/attractions*
> */ggfortunecookie.html*

Great China Herb Co.

This is a secret gem of a Chinese pharmacy that has been family owned and run in Chinatown since 1922. Manager Judy Ho-Lam offers an enormous selection of herbs used for both culinary confections and Chinese medicine.

> 857 Washington Street
> 415-982-2195

Li Po Lounge

Li Po is a cavelike cocktail lounge-slash–dive bar off Grant Avenue. Celebrity chef Anthony Bourdain has raved about the bar's Chinese mai tai, which has both attracted crowds and knocked them off their feet since 1997.

> 916 Grant Avenue
> 415-982-0072
> *www.lipolounge.com*

R&G Lounge

R&G Lounge is a large, three-story Cantonese-style dining room featuring a traditional menu. It's some of the best Chinese food I've ever tried, including the crab specialty and the Peking duck.

> 631 Kearny Street
> 415-982-7877
> *rnglounge.com*

The Wok Shop

An essential of Chinatown for more than forty years, the Wok Shop is a family–owned business specializing in hard-to-find Asian cooking tools that will enable you to execute any and every aspect of Asian-style dishes.

> 718 Grant Avenue
> 415-989-3797
> *www.wokshop.com*

NOB HILL

Huntington Park

A great place to find a quiet bench, take your kids to the playground, or meet up with your dog friends, Huntington Park is surrounded on three sides by Grace Cathedral and the Fairmont and Mark Hopkins hotels. The perfect spot to take in the views from Nob Hill and visit a bit of San Francisco's past.

> California and Cushman Streets
> www.sfparksalliance.org/our-parks/parks
> /huntington-park

The Royale

A down-home, no-fuss wine and beer bar known for its jam-packed schedule of fun events, including tastings, comedy nights, and funny drunken spelling bees. A great place to hang with a group of friends for cocktails.

> 800 Post Street
> 415-441-4099
> www.theroyalesf.com

Tonga Room and Hurricane Bar

An exotic getaway featuring a blue lagoon, faux tropical rainstorms, and a lava rock tiki bar, all nestled within the luxurious Fairmont hotel since 1945. This is where you come to try a cocktail served in a large bowl with two straws.

> 950 Mason Street
> 415-772-5278
> www.tongaroom.com

Top of the Mark

Go to the top floor of the Mark Hopkins hotel for the 360-degree panoramic view of the city skyline; stay for the martinis. The beautiful, somewhat pricey, yet unparalleled experience won't let you down. If you like to trip the light fantastic, there's even a live band to dance to on some evenings.

> 999 California Street
> 415-616-6916
> www.topofthemark.com

RUSSIAN HILL

Ina Coolbrith Park

A short trip up the stairs from the street is this lesser-known park named for the San Francisco poet. Just less than an acre, this park boasts some of the best views of both the city and bay. You may even catch a glimpse of the current residents—a brightly colored flock of wild green parrots.

> Taylor and Vallejo Streets
> 415-274-0291
> sfrecpark.org/destination/ina-coolbrith-park

Macondray Lane

After strolling through Russian Hill, I always seem to find myself at lush, green Macondray Lane. Made famous in Armistead Maupin's Tales of the City book series, there just can't be a prettier lane in the city.

> Between Leavenworth and Taylor Streets

Swensen's Ice Cream Parlor

With more than 180 flavors in its ice cream repertoire, this is the original Swensen's Parlor, which opened in 1948. It sits high up on Russian Hill overlooking the city: just walk up Union Street until you see the famous green neon sign.

> 1999 Hyde Street
> 415-775-6818
> www.swensensicecream.com

Vallejo Stairway Garden

Originally a goat path, these zigzagging stairs were converted in 1914 to a walkway through historic buildings and gorgeous terraced gardens. The wild green parrots like to hang out here in the lush, shady stairways.

> Vallejo Street, between Jones and Taylor Streets

THE MARINA

Crissy Field

This newly restored waterfront park is a fantastic place to go for a walk or a bike ride along the marsh. Stop for a picnic and take in the views of the bay, ocean, and Golden Gate Bridge from the perfect grassy green lawn and sandy beach area.

> 1199 East Beach
> 415-561-4323
> www.parksconservancy.org/visit/park-sites
> /crissy-field.html

Fort Mason

A former military base, Fort Mason has reinvented itself as a community haven—a dog park, a used bookstore, an educational center for art classes, an amazing community garden, and even the fantastic vegetarian restaurant Greens.

> 2 Marina Boulevard
> www.fortmason.org

Liverpool Lil's

Liverpool Lil's is the sister restaurant of the Brazen Head, so you know it has to be good. A cozy, classic pub-style bar with an eclectic menu and sidewalk tables, nestled right on the eastern edge of the Presidio, this is a great spot to take a break from the heavily occupied tourist attractions.

> 2942 Lyon Street
> 415-921-6664
> www.liverpoollils.com

Palace of Fine Arts

Originally built for the 1915 Panama-Pacific Exposition and since rebuilt, the Palace of Fine Arts stands among the beautiful lagoon and walkways as a tourist attraction, event venue, and host to rotating art exhibitions.

> 3301 Lyon Street
> 415-563-6504
> www.palaceoffinearts.org

The Warming Hut

After a day of exploring Crissy Field, make your way west toward the Warming Hut, a converted army warehouse, for a snack, a hot drink, fun park gear, or souvenirs.

> 983 Marine Drive
> 415-561-3042

PACIFIC HEIGHTS

Browser Books

Armed with a knowledgeable staff and selling books in San Francisco since 1976, Browser Books is a cozy little shop perfect for a leisurely afternoon perusing stacks of new and used books.

> 2195 Fillmore Street
> 415-567-8027
> www.browserbooks.indiebound.com

Clay Theatre

One of the city's last remaining original theaters, the Clay is consistently awarded and praised as one of the Bay Area's best spots to see a movie. Watch a film at the Clay amid the beautifully restored art deco and Greek-style interiors.

> 2261 Fillmore Street
> 415-561-9921
> www.landmarktheatres.com/market/SanFrancisco/ClayTheatre.htm

Jackson Fillmore

Jackson Fillmore is a Pacific Heights hot spot with fresh pasta and a family-style atmosphere. And don't be afraid to make a request—one of the best things about this Italian-style trattoria is the superb, personable service and the free slice of bruschetta that comes with every order.

> 2506 Fillmore Street
> 415-346-5288
> jacksonfillmoresf.com

Lyon Street Steps

Right at the southeast corner of the Presidio is where you'll find these steps on the edge of "Billionaires' Row," as it has been coined. Reach the top and you'll be rewarded with breathtaking views across the city.

> 2450 Lyon Street between Broadway and Green

HAYES VALLEY

Gourmet & More

Self described as being the only authentic French épicerie in San Francisco, Gourmet & More seems to transport you straight into the heart of Paris, with a lineup of colorful macarons and big wedges of stinky but delicious cheeses. The outdoor patio is a beautiful spot for lunch.

> 141 Gough Street
> 415-874-9133
> gourmetandmorestore.com

Miette

In the running for the city's cutest pastry shop, Miette creates works of art in the form of cake. The Hayes Valley shop is a sweet tooth's dream with old-fashioned candy, confections from around the world, and treats made by local artisans.

> 449 Octavia Street
> 415-626-6221
> www.miette.com

Smitten Ice Cream

Once operating out of a single red wagon, Smitten serves up "new old-fashioned ice cream" and makes everything to order—using liquid nitrogen to freeze the ice cream right in front of your eyes. Their innovative process produces some of the downright creamiest ice cream in the Bay Area.

432 Octavia Street #1A
415-863-1518
smittenicecream.com

Two Sisters Bar & Books

Come here for the sense of community and enjoy a classic cocktail or a coffee, snack on a well-crafted dish, and share Two Sisters' love of all things literary. The chamomile old-fashioned is the perfect nightcap.

579 Hayes Street
415-863-3655
www.2sistersbarandbooks.com

THE WESTERN ADDITION AND NOPA

The Independent

The Independent is a cozy venue in the city for enjoying "live music live" with an occasional Monday movie night. Legends of rock have played here, and loads of indie bands have gotten their start here.

628 Divisadero Street
415-771-1421
www.theindependentsf.com

Kinokuniya Bookstore

One of my favorite Japantown spots is the Kinokuniya Bookstore. I love the aesthetic of Japanese design books, and Kinokuniya has the best selection I've ever seen.

1581 Webster St #165
415-567-7625
www.kinokuniya.com/us

The Mill

A bright café-bakery collaboration between the ultra-talented team of Josey Baker Bread and Four Barrel Coffee. Their signature toast is quite possibly the best toast you'll ever try.

736 Divisadero Street
415-345-1953
themillsf.com

Rare Device

This shop lives up to its name. It's full of unusual rarities and one-of-a-kind gifts with a bit of kids' stuff thrown into the mix. The shop carries a wide array of accessories for your home, including some incredible artwork, and hosts regular gallery openings and events.

600 Divisadero Street
415-863-3969
www.raredevice.net

THE CASTRO

Books, Inc.

Opened in 1851, Books Inc. is a wonderful independent bookstore with multiple locations in the Bay Area. Their knowledgeable staff will help you find just the book you're looking for, regardless of the subject matter. Additional locations in Opera Plaza, the Marina, and Laurel Village.

2275 Market Street
415-864-6777
www.booksinc.net/SFCastro

Castro Theatre

With special screenings of classics and other fun events, the Castro Theatre is uniquely beautiful and one of my favorite places to go for a night out. An amazing space to see film classics and participate in the occasional sing-along!

429 Castro Street
415-621-6120
www.castrotheatre.com

Cliff's Variety

Cliff's Variety is chock-full of every kind of DIY, craft, cooking, and home maintenance gadget imaginable. There's a separate housewares department next door.

479 Castro Street
415-431-5365
www.cliffsvariety.com

Kite Hill

Kite Hill is not to be missed in the spring, when the entire hill turns bright green and ignites with native wildflowers like poppy, checkerbloom, and soap plant. It also boasts some of the best views of the Castro and downtown San Francisco.

Yukon and 19th Streets
415-831-6331
sfrecpark.org/destination/kite-hill

Urban Flowers

One of the most popular flower shops in the city, and quite rightfully so, Urban Flowers provides San Francisco with artful and unique floral arrangements at great prices.

4029 18th Street
415-355-1028
urban-flowers-arrangements.com

HAIGHT-ASHBURY AND COLE VALLEY

The Booksmith

The Haight's literary secret. Tucked in among tie-dye T-shirt shops, head shops, and cheap eats, The Booksmith is a wonderfully charming neighborhood bookstore with a super-friendly staff. Check their online calendar for regularly scheduled book readings and events.

1644 Haight Street
415-863-8688
www.booksmith.com

Buena Vista Park

Buena Vista Park is the oldest park in the city, named for its amazing views. Surrounded by beautiful old Victorian homes, it's a lovely San Francisco landmark full of walking trails.

Haight Street and Buena Vista Avenue E
415-819-2699
sfrecpark.org/destination/buena-vista-park

Kate's Kitchen

Kate's Kitchen is a Southern-style restaurant, and you'll know it as soon as you walk in. With red-checkered table-cloths and a hearty Southern breakfast and lunch selection, it's all comfort food at Kate's.

471 Haight Street
415-626-3984
www.kates-kitchensf.com

Wasteland

Wasteland is an eco-consignment meets thrift meets stylish warehouse offering vintage, designer, and independent labels to swap for your own wardrobe. Bring by your lightly used pieces to see what you can sell back.

1660 Haight Street
415-863-3150
www.shopwasteland.com

Zam Zam

Offering classic and specialty cocktails behind a vintage cash register atop an old-fashioned bar, with an old-school jukebox in the corner, Zam Zam is a great place to stop in for a good drink. Martinis are the specialty of the house.

1633 Haight Street
415-861-2545
zamzambar.com

Zazie

At this French bistro in the heart of Cole Valley, brunch is seriously not to be missed. On a warm day, sit outside on the pretty little patio.

941 Cole Street
415-564-5332
www.zaziesf.com

THE RICHMOND

Green Apple Books

A favorite of writer Dave Eggers and frequently noted as one of the best, Green Apple Books will transport you back to bookstores from your childhood. The huge piles and piles of new and used books are truly impressive.

506 Clement Street
415-387-2272
www.greenapplebooks.com

Kamei Housewares and Restaurant Supply

I love wandering this store and getting lost in its expansive collection of dinnerware and Asian cooking utensils and supplies. The main store is dedicated to the kitchen and the smaller storefront houses a combo of kitchen, bath, and general household items.

547 Clement Street
415-933-8508

Lands End

With rolling hills of wildflowers, cliffside views of the city, and winding trails with access to Sutro Baths and Mile Rock Beach, Lands End is a beautiful nature escape. Follow the trail all the way to the Cliff House for one of the prettiest hikes in the city.

Seal Rock Drive and El Camino Del Mar
415-426-5240
www.nps.gov/goga/planyourvisit/landsend.htm

Mountain Lake Park

A beautifully kept natural lake is the centerpiece of this park on the southern edge of the Presidio. It also has a nice dog run as well as numerous recreation facilities like tennis courts to enjoy. A hidden San Francisco gem.

98 Funston Avenue
415-831-5500
www.presidio.gov/explore/Pages/mountain-lake.aspx

Sutro Baths

Previously a massive bathhouse and swimming area back when it opened in 1896, it is now a collection of ruins along the cliffs of the Pacific, offering some fun exploring.

Point Lobos Avenue
415-426-5240
www.sutrobaths.com

THE SUNSET

Fort Funston

This former WWII military lookout perched on the edge of the Pacific Coast is now part of the Golden Gate Recreation Area, with beautiful hiking trails and a long, lovely stretch of beach where dogs are welcome off-leash.

Skyline Boulevard
415-561-4700
www.nps.gov/goga/planyourvisit/fortfunston.htm

General Store

You'll love the vintage vibe of this surfer chic shop, which has a well-curated selection of unique home accessories, objets d'art, books, jewelry, clothing, and unusual succulents. Be sure to visit the outdoor garden and greenhouse space.

4035 Judah Street
415-682-0600
www.visitgeneralstore.com

Mollusk Surf Shop

Branded as a surfing institution, Mollusk showcases surf culture in a friendly space rich with gorgeous colors and textures. Look for the stacks of surfboards and the giant wave-shaped sculptures through the window.

4500 Irving Street
415-564-6300
mollusksurfshop.com

Sigmund Stern Grove

At the corner of Sloat Boulevard and 19th Avenue is the thirty-three-acre Sigmund Stern Grove. In the summer months, this lush reserve is home to the super-fun Stern Grove Festival, a series of free musical concert events and a wonderful opportunity for evening and afternoon picnics while listening to great music.

Sloat Boulevard at 19th Avenue
415-252-6252
www.sterngrove.org

3 Fish Studios

A bright boutique and the brainchild of the talented husband-and-wife artistic team Eric Rewitzer and Annie Galvin, 3 Fish offers affordable artwork and creative goods with a superfriendly vibe. Check the online calendar for events and classes.

4541 Irving Street
415-242-3474
www.3fishstudios.com

CAPTIONS

Page 10, *bottom right:* Flowers of the Valley

Page 12: Buttons Candy Bar

Page 13, *top left:* Le Zinc French Bistro; *top right:* Chuck's Sun Valley Grocery; *bottom right:* Folio Books

Page 15: Goat Hill Swing, Glen Park

Pages 18-19: Alemany Farmers' Market

Page 21, *top left:* Hillside Supper Club; *top right:* Harvest Hills Market; *bottom right:* Flowercraft Garden Center; *bottom left:* Heartfelt general store

Pages 24-25: The view from Bernal Heights

Page 26: Clarion Alley Murals

Page 28, *top left:* Commonwealth; top right: Slow Club; *bottom right:* Mission Dolores; *bottom left:* Grand Theater

Page 29, *top left:* Slow Club; *top right:* Mama's Market; *bottom right:* St. Francis Fountain; *bottom left:* Uptown

Page 30, *top left:* Pizzeria Delfina; bottom right: Elbo Room; *bottom left:* Foreign Cinema

Page 31, *top left:* Rite Spot Café; *top right:* Atlas Cafe

Page 32, *top left:* Usulutan Pupuseria; *bottom left:* La Torta Gorda

Page 34: Mission Dolores Park

Page 38, *top left:* Parkside Café; *top right:* Farley's Coffee; *bottom right:* Potrero Hill Community Garden

Page 39, *top left:* Hilltop Grocery; *top right:* Collage Gallery; *bottom left:* Farley's Coffee

Page 40: Farley's Coffee

Page 41, *top left:* Hazel's Kitchen; *top right:* Blooms Saloon; *bottom right:* New Potrero Market

Page 42, *top left:* The Lab; *top right and bottom right:* Piccino Coffee Bar; *bottom left:* Piccino Restaurant

Page 43: The Lab

Page 44: Mission Creek Marina

Page 50: The San Francisco Flower Mart

Page 51, *top left and top right:* Flora Grubb Gardens; *bottom right:* All Good Pizza; *bottom left:* Flora Grubb Gardens

Page 52: Ferry Building

Page 54, *top left:* Ferry Building Farmers' Market; *top right:* Cowgirl Creamery in the Ferry Building; *bottom right and bottom left:* Ferry Building Farmers' Market

Page 56, *top right:* Sears Fine Food; *bottom right:* Hotel Des Arts; *bottom left:* Britex Fabrics

Page 57: Union Square

Page 60, *top left:* Aria Antiques; *top right:* Little City Market; *bottom right and bottom left:* Sodini's Trattoria

Page 61, *top left:* 101 Music; *top right:* Golden Boy Pizza; *bottom right:* Kennedy's Irish Pub; *bottom left:* Gino and Carlo Cocktail Lounge

Page 62, *top left:* Mashka Jewelry; *top right:* Al's Attire; *bottom right:* Vesuvio Cafe; *bottom left:* Italian American Club

Page 63: Goorin Bros. Hat Shop

Page 64, *top left and top right:* City Lights Bookstore; *bottom right:* Jack Kerouac Alley; *bottom left:* Grant & Green Saloon

Page 68: *top left:* Peking Bazaar; *bottom right:* Chinatown Gate

Page 69, *top right:* Eastern Bakery; *bottom right:* Buddha Lounge

Page 70: Li Po Cocktail Lounge

Page 71, *top left:* Empress of China

Page 74: The Fairmont Hotel

Page 75: Grace Cathedral

Page 78: The view from Telegraph Hill

Page 80, *top left:* Balustrade at Jones and Vallejo; *top right:* Russian Hill Dog Grooming; *bottom right:* No. 3; *bottom left:* Macondray Lane

Page 81: Macondray Lane

Page 82, *top left:* Gioia Pizzeria; *top right:* Swensen's Ice Cream; *bottom right:* Verbena; *bottom left:* Leopold's Gasthaus

Page 83, *top left:* Alhambra Theater (now Crunch Fitness); *top right:* The Brew; *bottom right:* Pesce; *bottom left:* David's Tea

Page 84: Crissy Field

Page 86, *top left:* Presidio Theater; *bottom right:* All Star Donuts; *bottom left:* Marina Super Market

Page 87, *top left:* Fort Mason Farmers' Market; *top right:* Surf Motel; *bottom right:* SusieCakes Bakery; *bottom left:* Liverpool Lil's

Page 88, *left:* Palace of Fine Arts; *right:* Crissy Field

Page 89: Crissy Field

Page 91: Fort Mason

Page 96, *top right:* The Grove; *bottom right:* Shabby Chic

Page 97, *top left:* Browser Books; *top right:* George Pet Store; *bottom right:* The Ribbonerie; *bottom left:* Mudpie

Page 100, *top left:* Two Sisters Bar and Books; *top right:* Bar Jules; *bottom right:* Proxy; *bottom left:* Absinthe

Page 101: Patricia's Green

Page 102, *top left:* Marine Layer; *top right:* Smitten Ice Cream

Pages 103 & 104: Miette

Page 105: *top left:* Miette; *top right:* Loving Cup; *bottom left:* Chantal Guillon Macarons

Page 106: The Painted Ladies

Page 108, *top left:* Rare Device; *top right:* Nopa; *bottom right:* The Mill; *bottom left:* Noc Noc

Page 109: Scents-U-All

Page 110, *top left:* Benkyodo; *bottom right:* Rooky Ricardo's Records; *bottom left:* Underground SF

Page 111: Japantown

Page 114: Castro Theatre

Page 117, *bottom right:* Kite Hill

Page 119: Urban Flowers

Page 120, *top left:* Réveille Coffee Co.; *top right:* H Café; *bottom right:* Twin Peaks Tavern

Page 121: Castro Theatre

Page 124, *top right:* SwayChic; *bottom right:* Amoeba Music; *bottom left:* Earthsong

Page 125: Zam Zam

Page 128: Sunny Country Foods

Page 129, *top left:* Sunny Country Foods; *top right:* Tantrum; *bottom right:* Padrecito; *bottom left:* Cole Garage

Page 130, *top left:* La Boulange de Cole; *bottom right:* Doug's Suds; *bottom left:* Zazie

Page 131, *top left:* Alpha Market; *bottom left:* Tank Hill

Pages 132, 134-135: Sutro Baths

Page 136: Green Apple Books

Page 137, *top left and top right:* Seedstore; *bottom right:* Park Life; *bottom left:* Seedstore

Page 139, *top left:* Blue Danube Coffee House; *top right:* Toy Boat Dessert Café

Page 142, *top left:* Park Chow; *top right:* Sunset Shoe Repair; *bottom right:* Stow Lake Boathouse Café; *bottom left:* Pasquale's Pizzeria

Page 143, *top left and top right:* San Francisco Conservatory of Flowers; *bottom right:* Stow Lake Boathouse Café; *bottom left:* Golden Gate Park and the DeYoung Museum

Page 144: General Store

Page 145, *top left:* Roberts-At-The-Beach Motel; *top right, bottom right, and bottom left:* General Store

Page 146, *top left:* Aqua Surf Shop; *top right:* Mollusk Surf Shop; *bottom right:* 3 Fish Studios; *bottom left:* Ocean Park Motel

Page 147: Ocean Beach

Page 148, *top left:* Mollusk Surf Shop; *top right:* Fort Funston; *bottom right:* Tuesday Tattoo; *bottom left:* Fort Funston

Page 149: Fort Funston

ACKNOWLEDGMENTS

My deepest thanks first and foremost go out to my readers: this book would not have been possible without you. To my friends and fellow artists, thank you for your generous support and for inspiring me to see beauty in the odd and the unusual every single day. A special thanks to my mom and dad for putting that very first camera in my hands and allowing me to capture the world as I see it, even when a little bit offbeat. To Tod and Tammi for all the love, and to Alexis and Madison for making the future so bright. Thanks to the Dog Park Crew: you are the wind beneath my wings. And to Cindy Loughridge, Anna Dorfman, and Suzanne Shade for helping me put the pictures on the page. Thanks to FJ for doing nothing but making me laugh. To my agent, Judy Linden, for not allowing me to throw out the baby with the bathwater, and to my editor, Laura Lee Mattingly, for her undying patience when I kept saying "no" and her enduring guidance through the long process that is birthing a book.